Francis Bacon:
Painter of the Invisible

P.T.Miles

authorHOUSE

AuthorHouse™ UK Ltd.
500 Avebury Boulevard
Central Milton Keynes, MK9 2BE
www.authorhouse.co.uk
Phone: 08001974150

First published by AuthorHouse 1/20/2011.

ISBN: 978-1-4520-9723-7 (sc)

This book is printed on acid-free paper.

Contents

Introduction.

Before presenting this short study I will explore a number of issues that will go some way towards delineating my approach to Francis Bacon's *oeuvre*. First and foremost - **WHY WORDS** – why is it necessary in order to comprehend a work of art does there have to be thousands upon thousands of words? Is this a cultural phenomenon peculiar to Anglo-Saxon culture? Partly this is true for the British mentality, in general, is more predisposed to the Literary and Music, at least until recent times where post-modernism and globalisation are radically shifting cultural assumptions associated with by-gone years. However, regardless of any purported cultural difference between nations and races, it is now universally accepted that the **WORD** is now the prime medium for the conveyance of meaning, and this, in turn has led to the realisation that there is in fact a 'tyranny of the word', whereby the focus in the search for meaning becomes the word whilst the object under discussion plays at best a secondary role.

A complete response as to why the word dominates is not possible here, but I will present a few lines of enquiry that at least indicate reasons for this occurrence. I hope there will be very little disagreement if I state that the defining characteristic of present-day consciousness, and by default epistemology, is that of abstraction and intellectuality, whereby concepts (ideas) are considered and manipulated by an abstract thinking that is ruled by the laws of Logic. Ideas and conceptualisations of every shade thinkable are only deemed to be tenable if they are shown to be *logical*. So far so good, but it cannot be ignored that for logic to be effective it has to rest upon principles and assumptions, from which to argue, that are considered by their very nature to be unquestionable, fundamental and unassailable – in a word **TRUE.** Given that the present epistemological bias for the determination of truth is slanted towards materialism then logically any argument proposing that spiritual principles play any part in the coming-into-being of ourselves and the Cosmos, and subsequently knowledge of these, must be regarded as unacceptable by a materialist.

1

Pure science prides itself upon the fact that its materialistic postulations are rendered credible and truthful by Mathematics. Mathematics because it has an unproblematic relationship between its symbol and what it stands for (signifier/ signified) i.e. 1 is 1, is ideally suited for the management of abstract concepts, and as such is the epitome of abstract thinking. The case is different for language and the word, for here the relationship between meaning and symbol is complex, using the above example 'one' could mean myself, any single entity or completeness and so on. The upshot is that for so-called scientific purposes language has to be shorn of its richness so that it is better fitted for the deployment of abstractions, meaning that there is a subtle but invasive mechanisation of language shadowing the dominance of the intellect in our consciousness. At present there is no such thing as a mathematics of, for instance, Beauty, and to suggest the possibility that there could be would, at the very least, invite ridicule. The lack of such, however, cannot hide the knowledge that Beauty is a very real and knowable facet of human experience, even if it is impossible to distil from experience or find any entity that expresses pure, unalloyed Beauty. From this the understanding arises that we inhabit a world where there are concepts that are considered to be real but for which there is no definitive 'thing', and Beauty is not the only concept that fits this category. Realisation that there is a conceptual hierarchy within our thinking precipitates an altered awareness towards the created universe. To take another more mundane example, one observes a 'dog' but one does not ordinarily perceive it in its conceptual purity only its particularity, notwithstanding the fact that without there being subconsciously an awareness of this conceptual purity recognition that a creature before one as being a 'dog' would not be possible. The epistemological import of such considerations is that a conceptual hierarchy exists whereby some concepts are woven more deeply into matter than others, and unless one is an epiphenomenalogist believing that all qualities are a *fata morgana* arising from the machinations of dead matter, then it has to admitted that there are concepts that are real but which cannot be perceived in their essence, only perceived as being reflected to a greater or lesser degree in the phenomena of the world. That is within all the concepts knowable there is only a portion that manifest as percepts. To take the argument further, Growth is such a concept, for everyone can see that organic entities grow, but we cannot perceive actual 'growth' even if one were to take the naïve stance of staring at a plant. However, if it is accepted that a salient feature of plant life is that of a metamorphosis of one form into another (leaf into petal etc.), then there is a branch of mathematics that renders the development of a plant comprehensible – and this is Projective Geometry. Through the deployment of Projective Geometry comprehension of the, to start with, nebulous concept 'growth' is sharpened and placed on a firm mathematical footing, thereby bringing order to the 'lived experience' (phenomenology) of the invisible worlds of thinking (pure concept: growth) and the sphere of action of 'growth' in bringing forth the flora and fauna of nature. Projective Geometry has the dual effect of fostering awareness of how number is enfolded into form on its most essential level (quantitative measurement is subsidiary to the qualitative understanding fostered by Projective Geometry, for as can be readily appreciated a quantitative measurement is exterior to a form whereas a forms qualities are inherent to it) albeit in an abstract manner, and inspiring the imaginative side of human nature through pondering upon the metamorphosis into each other of forms that lie at the heart of the Cosmic creativity.

Returning to the theme that we now rely upon the intellect and abstraction as the principal means of comprehension, has this always been the case and is there any proof that consciousness has altered over the centuries? Certainly we can contemplate two individuals standing at the start of the modern era without whom Art History in its present form would not be possible, and these are Giorgio Vasari (1511-1574) and Johannes Gutenberg (1400?-1468). With the publication of his book "Lives" Vasari gives a biographical account accompanied with a chronological listing, that included a rating as to their importance, of what were considered to be the leading artists at that time, both past and present. This initiated a methodology that has been greatly refined and revised so as to constitute a principal form of Art Historical criticism. During the Renaissance the hegemonic standing of Catholicism was eroded and with this decline its power over pictorial interpretation was also diminished and Vasari's "Lives" is proof of this as the first secular critique upon Art to find widespread acceptance and, furthermore, a wealthy class of individuals (the Medici's and others) emerged during this period who desired works of art exploring knowledge and understanding (Humanism) outside the doctrinal limitations of Catholicism. This meant that the Church was no longer the sole means of a livelihood for an artist and has eventually led to the proliferation of styles and schools that are now known. Prior to Guttenberg there clearly was no mass availability of books and printed images, and literacy was restricted to a privileged few within the ambit of the Church. So how did humanity, in general, comprehend the world? At this point it is necessary to state that the above referred to the *written* word and not the spoken word, quite apart from the truncation of the written word for epistemological reasons there is a gulf between the immediacy and power of the spoken word and the written word. It follows that preceding Guttenberg humanity was far more responsive to the spoken word and images (due to their scarcity), simply because their sensibilities had not been dulled by the ease of access to the sheer bulk of printed words and images available today (disregarding for the moment other mediums such as television and film). If this is the case then the imaginative life of an individual would have been far more vital and alive, and consequently would have been more receptive to the language of art, which, therefore, would had a greater epistemological impact.

Whatever status one accords to the Renaissance it is undeniable that discoveries and developments took place during this period that have irrevocably changed our comprehension of the world. Foremost, here is the recognition that Giotto (1266?-1337) recorded in his work changes that were taking place in human consciousness from the heavenly towards the material and earthly and, in this respect, he strove to depict the perceived corporeality of a human being in his figuration. The accompanying blossoming of intellectuality was pictorially depicted by Raphael (1483-1520) in his work "The School of Athens". The belief that human reason alone was capable of solving humanities problems and ontological questions, as exemplified by Rene Descartes (1591-1650) iconic statement "Je pense, donc je suis" (Cogito ergo sum) , became fully explicit during the Enlightenment, and has fostered the eventual creation of a secular society and a scientific methodology for epistemological enquiry. The purging of the Irrational, whether as religious beliefs or conceptual forms (Alchemy and Astrology for instance), from Knowledge in favour of abstract, intellectual concepts has had a number of unfortunate consequences. Principally, in this context, it has led to a hierarchy of Knowledge whereby the abstract and intellectual thinking associated with the scientific

method has been valorised to the detriment of artistic thinking (Imaginative), indeed Emmanuel Kant (1724-1804) gave this prejudice a philosophical 'gold-plating' by stating that artistic cognition had no epistemological value for the determination of 'truth'.

The attempt to cognise the world through abstract, intellectual thinking alone has led to the reduction in that which it is permissible to consider, i.e. the qualities of touch, taste, smell etc. have been down-graded to a secondary status with respect to size, weight and number, simply because these aspects of phenomena are more easily computable than the former. This strategy designed to meet the limitations of mathematical knowledge (John Locke, 1632-1704), produces a diminution in the range of phenomenological information available for scientific research, and it is not difficult to perceive how this strategy leads to the aridity of present-day abstract thinking with its denuded conceptual framework. Likewise, because religious conceptualisations became problematic, the attempt has been made to cognise the human being in terms of the body alone, generating a purely mechanistic and material paradigm of the human being within which the emotional dimension of the human being becomes problematic, thereby making a philosophical pariah out of our most important and divine facet: the ability to have emotional responses to the phenomena of the cosmos. It might be asked how it is now possible to have any epistemological veracity given that there is now no over-riding, all-knowing deity to vouchsafe any speculations. In one sense the development of logical thinking has safeguarded knowledge from outlandish and extravagant assumptions, but as the premises of any theory logically proposed are not immune to error logical thinking cannot be an ironclad guarantee that a theory is 'true'. There have been many universally accepted theories regarded as logical and true in their time that have been shown to be deficient and erroneous when new evidence comes to light. Overwhelmingly mathematics has become the standard by which the veracity of theorisations stands or falls, this is self-evident with the 'hard' sciences but it has long been the goal of Social Sciences to emulate this by discovering mathematical paradigms that guarantee their own conceptualisations in a similar manner. Because the quantitative facets of phenomena are so easily computable an inevitable imbalance has occurred towards materialism that behoves the need for a new thinking that can cognise the derided, poor-sister of knowledge -the qualitative- and every time radical re-evaluations of the material world arise, as with Einstein's revision of Newtonian mechanics, so the opportunity arises for this to occur. *Human consciousness is not static but constantly evolving* and as new faculties appear within consciousness these engender a new experiential understanding that can only become epistemologically coherent if there is a corresponding evolution of the conceptual framework deployed for cognition.

When there are no mathematical proofs for theoretical speculations, as with the Arts, other tactics have to be embarked upon. Within the academic institutions of a Culture various intellectual hypotheses surface that have only a limited life-span the favourability of which appear to depend more on fashion than concrete knowledge (in the mathematical sense), witness the rise and fall of Dialetical Materialism, Semiotics, Structuralism etc., a situation that gives the impression of an intellectual, piece-meal quagmire that possesses no authoritative centre. One solution to this has been to speculate that there exist quasi-real phenomena occupying metaphysical realms adjacent to ordinary experience that can, some how, have a 'real' effect upon consciousness, how we behave, or how we create

meaning etc. (signifiers and so on). A process of reification then takes place that attempts to give these purely speculative entities a phenomenological, palpable existence, and 'atoms' (as conceived by the scientific community as being composed of electrons etc.) are a prime example of this speculative process. The crucial difference between 'signifiers' and 'atoms' is that the latter can be proved to be mathematically credible whereas the former, despite the efforts of Jacques Lacan and others have no such backing. Even though 'atoms' suffer from the same weakness as 'signifiers', in that they are purported to dwell in some imagined metaphysical realm of 'matter' outside of human lived experience, no doubt the scientific community, as such, would argue that a technology and instrumentation exists that underwrites the mathematical proofs. But this is a complete obfuscation of the facts for any instrument (electron microscopes, spectrometers etc.) is an **idea** given a material form with a predictive, graded system of measurement built into it and can only construe the world in a blunt and degraded style. An instrument does not provide any 'proofs' for any results obtained have to *interpreted,* and by default interpretation can only take place within the parameters of the instruments own construction, and these were conditioned by the assumptions concerning that which is measured, thus creating a closed circle predicated on its own making that excludes *reality*.

Above, I pointed out how works of art have been subjected to the 'tyranny of the abstract word' and are in the main lost sight of, but can there ever be any equivalence between words and images? This is an important question for an essential strand of post-modern thinking is that words have no meaning, in the sense that the connection between the word and what is referred to is unauthentic and non-verifiable – words are only labels. This is the world of abstraction triumphant and if true begs the question as to whether there exists any real world independent of its representation in any form? To my mind, and I offer reasons (the dominance in thinking of intellectualism), this is patently absurd and leads to the sort of foolish conclusions where there is assumed to be no qualitative difference between the Sublime and the Ridiculous, and that it is only a matter of choosing between the alternatives thereby reducing experience to the level of consumer choice. Because language is expressive, and this applies to both the spoken and the written word, there has to be an inherent slippage to words, otherwise there could be no individual expressiveness only universal expression *per se*(absolute abstraction). On the other hand there has to be a central core of meaning that is stable, for without this communication would be impossible. Thus language resembles an over-ripe fruit whereby the soft outer layer is alterable and movable but nevertheless is anchored to a hard, solid centre.

If humanity gains knowledge and understanding through the unification of a concept with its percept, i.e. when the concept 'tree' is aligned with the observation of a tree then we immediately know what we are looking at, then this is where thinking *transcends the weaknesses and strengths of any language.* Drastically put it does not matter what word describes a tree for the knowing, within consciousness, of the 'concept' tree must be the same for literally everyone for a percept of a tree to be universally acknowledged as such, and the translation from language to language of the word serves to point an individual in the direction of the concept in question. To continue with the above, 'growth' is considered to be a real process absolutely essential to any organism, but which is imperceptible to normal consciousness, making it a 'real' concept that has no percept. However, 'growth' is

5

a vital component of 'life', and 'life', as such, has the possibility of being 'intuited' or sensed (for instance when in the presence of a pregnant woman). This ability we posses, regardless as to how refined it is, brings awareness of the nascent cognitive power of our emotional capacities and indicates higher levels of 'sensing' than that provided by the corporeal sense organs. This dimension of our being is as yet under-utilised, and as discussed has even been excluded from epistemology, with respect to its cognitive potential due to a lack of serious investigation.

From the above analysis it becomes apparent that I have investigated three realms pertinent to a human being that are 'real' but imperceptible: the forces of growth, emotional responses and thinking, and henceforth these will be referred to as the body of Formative Forces (sometimes the etheric body), the Astral body (sometimes the emotional body or Soul) and the Spirit, which here principally concerns Thinking along with its concepts and the Ego, respectively. Of the three kingdoms of nature - mineral, vegetable and animal – it is only the human being, as a higher development of the animal kingdom, that possesses all three of the above realms in conjunction with its corporeal body (mineral), the others in order of descent are the animal – mineral body, Formative Forces body and an Astral Body – the plant with a mineral body and a Formative Forces body whilst the minerals have only a mineral body that is influenced by etheric forces from without. The animal because it has an Astral body has a picture-based consciousness but does not have self-consciousness as that is only possible for a creature that possesses an Ego, namely ourselves. The animal does not think in pictures because it has no awareness that it has pictures to think with but the human being does, and this fact brings to light the other ability the thinking human being is able demonstrate. Thus thinking for a human being is comprised of two discreet modes: the Intellectual and the Imaginative, neither of which, by itself, is able to furnish a comprehensive knowledge of the world. Logic governs the intellectual which concerns itself with the manipulation of abstract concepts and abstract symbols whereas the Aesthetic regulates Imagination and picture consciousness. Intellectually we are able to prove anything we please so long as there are acceptable principles to argue from, whilst the Imagination has the tendency to become disorganised and descend into wild fantasy conjuring up forms that bear little logical connection to the 'real' world. If as conjectured neither the scientist nor the artist is able to provide epistemologically satisfying accounts of ultimate questions (such as where do I come from?), what is the way forward.

The most obvious response is to ask what are the possibilities if an individual is able to integrate the two modes of comprehension, and are there any historical figures generally known to the public that have done so? The answer is yes, but for this to happen the Intellectual and Imaginative modes of thinking have to be drastically transformed, for nothing will spring from their present state. The historical figure who transformed his thinking so that intellectuality and imagination demonstrate a higher order of organization and possibilities is Johan Wolfgang von Goethe (1749-1832). It is generally very little appreciated that during his lifetime Goethe had a considerable reputation as a Natural Scientist, and undertook research in many diverse fields (see Henri Bortoft's book "The Wholeness of Nature: Goethe's Way of Science). Goethe was not content with a one-sided intellectual interpretation of natural phenomena (Isaac Newton's 'Theory of Colour' for instance), but strove to combine his intellectual conclusions with his imaginative capacities.

This *modus operandi* is unambiguously demonstrated by his efforts to cognise the plant realm. Goethe did not simply take a plant and divide it into its constituent parts (Linnaeus), naturally he was aware of the parts of a plant, but went out into nature and observed how these parts altered according to the environment in which they grew, by doing this Goethe honed his empirical observations thereby broadening his range of abstract concepts so that his intellectual capacities had a more complete 'picture' from which to theorise. Alongside this intellectual activity Goethe carried within his imagination images of all the different stages of plant growth, and tried to envision how, imaginatively, they metamorphosised into each other. This process carried out over many years finally yielded what he named the Ur-phenomena (the governing Principle) of not only specific plants but of the whole of the plant realm. That is he had a *living picture* in his consciousness of that which regulates the growth forces of a plant so that it is able to develop, and this was not merely an intellectual and abstract concept. Goethe named this methodology Exact Sensorial Fantasy (ESF), and this methodology together with his other ideas are largely forgotten and ignored, partly due to the fact that Goethe was no Philosopher or Mathematician and so was unable to formulate his ideas into a Theory of Knowledge.

The human being is aware of two worlds with which it has only a tangential relationship: the inner and the outer. Of the outer world the human being only perceives the physical appearance of phenomena and not the forces that give rise to the phenomena, whereas inwardly the human being knows thoughts, ideas, images and so on but again is not cognisant of the forces from which they arise. There is, however, a radical difference between them, with the outer an individual has no influence over that which enters consciousness through their sensory organs, but this is not the case for the inner world for here the individual has some influence over the ideas, thoughts, images and emotions that comprise the mental landscape of our inner world. With regard to the outer world if we consider that in the process of 'sensing' we 'digest' it by uniting the percept with a concept, then it follows that our relationship to the outer world is dependent upon the sophistication of our conceptual world. Alternately, our connection with our inner world of concepts is transformed when 'pure' concepts are considered, thus contemplation of the concept 'growth' is different from contemplating something that exhibits growth, in essence this is 'thinking about thinking' and when practised develops a conceptual framework more in harmony with the created world. For, from the above, it can be seen that from a particular point-of-view the phenomenal world consists of coagulated concepts that are only partially revealed to us through our present sensory capabilities and thinking.

With regard to the reality of a 'Body of Formative Forces' and an Astral Body there exists enough literature of a suitably scientific nature concerning 'invisible' realms to cause any one pause for thought, irrespective of whatever name is given them. For instance, Rupert Sheldrake through his botanical research has arrived at the conclusion that an 'invisible' force, which plays a vital role in the coming-into-being of plants, exists that he has named a 'morphic' field, and which evinces specific properties such as 'morphic' resonance ("Dogs that know when their Owners are Coming", "A New Science of Life"). Other examples are Lynne McTaggart who in her book "The Field" draws attention to the existence of 'invisible' forces (Zero Point Field) that affect everyday life, whilst Dean Radin, Ph.D., ("The Conscious Universe: The Scientific Truth of Psychic Phenomena") conducts a through investigation into

experiments designed to test for evidence of psychic abilities in individuals using the latest statistical models, and one conclusion of his research is that although it is undeniable that humanity, as a whole, possesses psychic capacities it is not possible to prove that a particular individual is in possession of such powers.

Francis Bacon's work is exclusively concerned with both the inner and outer dimensions of human consciousness and how the body is situated within space. His interest was not specifically, therefore, with the surface appearance of our corporeality or with the bones, tissue etc that make up a body, rather he was concerned with the 'invisible' forces that give rise to these components and how these components react under the impact of 'invisible' emotional forces issuing from the inner world when someone is under stress, suffering mental disintegration, sexual excitement or any other associated state. These emotional forces as referred to in this text have a wide range. Some explanation is needed. Absolutely basic to any human being are our instincts: hunger, thirst, shelter, warmth and procreation. There is nothing we can do about these they are a fact that is the core of our commonality with mammals; our animal nature. These instincts/ needs become drives when focussed upon an object perceived as capable of satisfying them (note here that sexuality is different from the urge to procreate). The success or not of our drives is aided by the fundamental five senses of hearing, taste, feeling, sight and smell all of which have pleasurable sensations associated with them that are judged to be good or bad. These pleasurable sensations evolve into desires, likes and dislikes, but are different from passions. Desires are utterly within the ambit of an individual's personality whereas there is an ideal dimension to a passion that is capable of ennobling a human being by momentarily lifting them out of the cauldron of their desires. Nevertheless passions can be abused when they descend into fanaticism. When referring to emotional states etc below this is the sense meant. Thus Bacon's paintings, from my perspective, investigates the interaction of Formative Forces and the Astral body in the human being from the perspective of a narrow band of emotional states. As will be demonstrated it is possible to discern in Bacon's *oeuvre* an understanding of *all* the tenets of Projective Geometry, and it is a pertinent question as to why it is that this work is so enduring and commands prices in the millions. I am arguing that those analyses of Bacon's work that rely heavily upon such free-floating factors as sexuality, violence and mental instability bereft of any meaningful context undersell and demean the significance of Bacon's paintings. It is a simple fact that work that exhibits such factors alone do not stand the test of time and quickly fade into obscurity, for there is nothing so boring and tedious as such work once the initial frisson withers.

Chapter 1. Beginnings.

The aim of art is not to represent the outward appearance of things, but their inward significance—Aristotle.

It is perhaps something of an understatement to say that Francis Bacon is a controversial painter. The fact that his work has given rise to so many divided opinions is surely proof enough. In the English speaking world, naturally enough, credence is given to those accounts, such as, John Russell's "Francis Bacon", that are widely available through their appearance in the native tongue. These British accounts display a great degree of consonance with regard to the significance of Bacon's images and his motives for production, and so over time, since their basic tenets remain unchallenged - an interpretive edifice has been constructed that has the aura of authenticity. What this 'British perspective' obfuscates, through disregard and omission, is the fact that there is a substantial body of readings of Bacon's *oeuvre* that have a Continental origin, and that these Continental readings serve to destabilise and 'call into question' what may be called an Anglo-Saxon empirical interpretation of Bacon's *oeuvre*. This is still substantially true today, although in recent years other continental commentators on Bacon's work have become available. (see Conclusion).

Gilles Deleuze and Ernst van Alphen are two prominent Continental writers who have produced far-reaching interpretations of Bacon's paintings, and extensive use of their texts will be made in what follows. Both these authors are more willing, than their British counterparts, to include in their analyses of Bacon's images post-modern issues and questions, for instance van Alphen considers, in detail, Bacon's declared aim that he wished to eschew any 'narrative' element to his work alongside post-modern notions of the role and function of language. Where the British perspectives score heavily is with their belief that Bacon's images are inextricably linked to questions pertaining to the Human Condition (Russell's book is seminal in this respect). The proposition is that there is an ontological dimension to Bacon's *oeuvre* that directly evokes what it is like to **live and feel** as a citizen of the modern world. Whilst inspiring one cannot escape the conclusion that these British accounts are biased, inward looking and have the feel of being frozen in time, and that definitive deductions are constructed from the flimsiest of evidence.

Russell expends much energy in an effort to demonstrate that some of Bacon's early work was motivated by Bacon's knowledge of events in Nazi Germany during W.W.11 and

Totalitarianism, even though Bacon denied such a connection in conversations with David Sylvester.[1]

D.S. "So it's the same thing as when you've painted figures inside a sort of space-frame and its been supposed that you were picturing someone imprisoned in a glass box."

F.B. "I use the frame to see the image – for no other reason. I know its been interpreted as being many other things."

D.S. "Like when Eichmann was in his glass box and people were saying that your paintings had prophesised this image."

F.B. "I cut down the scale of the canvas by drawing in these rectangles which concentrate the image down. Just to see it better." [2]

If an artist's comments are to be taken seriously, and there is no reason not to do so in this case, for what stands out in Bacon's conversations is a consistency and candour over a long career that lacks any pomposity, self-aggrandisement and, importantly, artifice, then one is obliged to look to other factors for the appearance and affect of his work. This is particularly true when it is almost implied that Bacon had a morbid interest in 'violence', and so can we really naively assume that the famous open mouth that is a salient feature of this early period is purely a terrified figure screaming and nothing else? When questioned on this subject Bacon had the following to say

F.B. "..I did hope to make the best painting of the human cry. I was not able to do it ... I think probably the best human cry in painting was made by Poussin ... a second-hand book which had beautiful hand-coloured plates of diseases of the mouth; and they fascinated me

D.S. "The open mouths – are they always meant to be a scream."

F.B. "Most but not all. You know how the mouth changes shape. I've always been very moved by the movements of the mouth and the shape of the mouth and teeth...."

D.S. "So you might well have been interested in painting open mouths and teeth even if you hadn't been painting the scream?"

F.B. "I think I might. And I've always wanted and never succeeded in painting the smile."

Similarly when asked about the violence and horror that is associated with his images Bacon had the following to say:

D.S. "It seems to be quite widely felt of the paintings of men alone in rooms that there's a sense of claustrophobia and unease about them that's rather horrific. Are you aware of that unease?"

F.B. "I'm not aware of it. But most of the pictures were done of somebody that was always in a state of unease, and whether that has been conveyed through these pictures I don't know. But I suppose, in attempting to trap this image, that, as this man was very neurotic and almost hysterical, this may possibly have come across in the paintings. I've always hoped to put over things as directly and rawly as I possibly can, and perhaps if a thing comes

across directly, people feel that that is horrific. Because, if you say something very directly to somebody, they're sometimes offended, although it is a fact. Because people tend to be offended by facts, or what used to be called the truth." 3.

Thus Bacon desired to represent the existential facts unreservedly and completely, and that because of a viewer's, or critic's, particular mind-set and 'conditioning' this was found to be 'horrific' or 'violent', something that might not possibly occur to a person of a different cultural background, a Japanese person let us say, to them it might be an interesting representation of how things are.

Gilles Deleuze tackles this issue of a graphic representation of violence head-on right at the start of his book "Francis Bacon: The Logic of Sensation",

"Francis Bacon's painting is of a very special violence. Bacon, to be sure, often traffics in the violence of a depicted scene: spectacles of horror, crucifixions, prostheses and mutilations, monsters. But these are overly facile detours, detours that the artist himself judges severely and condemns in his work. What directly interests him is a violence that is involved only with color and line: the violence of a sensation (and not of a representation) When Bacon distinguishes between two violence's, that of the spectacle and that of the sensation, and declares that the first must be renounced to reach the second, it is a kind of declaration of faith in life." 4.

This insight by Deleuze based upon Bacon's own admissions brings us to the hub of any meaning that may be attributed to Bacon's images for Bacon's interest is not with the particularity of instances of 'violence', or 'horror', or even 'sexuality' but with those forces, those 'sensations' that are bound up with such situations. Of course it cannot be ignored that these 'sensations' have a particularity, but in the process of reaching these 'invisible' forces - all emotions and sensations are invisible to ordinary vision - Bacon had to resort to a complete pictorial re-evaluation of what it means to depict the human figure. Otherwise one collapses into the narrative and 'story-telling'; that is one starts to read in sequences of cause and effect in the works that relate to events as they occur in everyday life. If Bacon had allowed this to happen we could then accuse him of 'sensationalism', but he did not and strived on every level to prevent this from transpiring.

Deleuze explains this distinction between the 'spectacle' and the 'sensation' as a difference between the figural and the 'Figure', where the figural refers to the attempt to create an isomorphic copy of a human being through a tried and tested formula of pictorial codes - the mimetic - and is that which appears 'realistic' to our ordinary vision, and where, in contrast, the 'Figure' is a dismantling of these codes, after which there is a re-assembling, so as to create that which is analogous to the reality of a human being pictorially - the 'Figure'. The purpose of which, for Bacon, was to lay bare, to make palpable and tangible, the invisible but all-powerful range of emotions a person is capable of experiencing. As Deleuze reminds us this attempt to make visible the invisible has been a concern of painting from the mid 19th. Century up until the present, for instance Cezanne, van Gogh, and Kandinsky. With the artists so far mentioned this desire was an unquenchable thirst that could not be relinquished until some success was achieved, regardless of whatever form it took. Paul Brunton echoes Deleuze's sentiments when he states of the visual arts that,

"When they fulfil their highest mission, painting and sculpture try to make visible the invisible, unimaginable mystery of pure Spirit."[5].

This is not to say that human distress is irrelevant to Bacon's intentions for what is the significance of the mouth? As Bacon puts it, and this is true anyway, the mouth and how it changes shape reflects a person's inner state of being and Bacon was particularly sensitive to this. So for Bacon the mouth was a visible gateway that could be investigated so as to gain insights into that which is invisible - the emotional state of the person viewed – if you like their soul. Bacon confirmed this in an unedited extract from a film that no longer exists produced in Wheeler's restaurant in 1958 when in conversation with Daniel Farson he stated

"...there was a very interesting thing that Valery said ... that modern artists want the grin without the cat and by that he meant that they want the sensation of life without the boredom of its conveyance ... how can I draw one more veil away from life and present what is called the living sensation more nearly on the nervous system...". [6].

The assertion, within the British tradition, that Bacon's images are of 'questionable taste' (see Frank Whitford and Peter Fuller) ignores the realisation that Beauty in its true essence is 'terrifying', in that it 'violently' disrupts our sensual appreciation of the world and often assumes the form of the 'bizarre' and the 'ugly'. This is important when assessing Bacon's images and his fascination with Greek tragedy, for the 'ugly' and the 'bizarre' should not present any barriers to our approach to his work, as Rudolf Steiner (1861-1925) states

"All genuine art seeks the spirit. Even when an art wishes to represent the ugly, the disagreeable, it is concerned, not with the sensory disagreeable as such, but with the spiritual, which proclaims its nature in the midst of unpleasantness. If the spiritual shines through the ugly, even the ugly becomes beautiful. In art it is upon a relation to the spiritual that beauty depends." [7].

The position of Rudolf Steiner in this interpretation of Francis Bacon's paintings is twofold. Firstly he acts as a primary source to substantiate statements made, regardless as to whether those statements are considered to be controversial or not, and certainly Rudolf Steiner is thought within certain circles to be so. Secondly, and this is more important in the long run, it is made plain that Steiner deployed a particular methodology in his examination of the natural world and that this led to the conclusions that he made concerning the genesis and development of natural phenomena. These results are documented in his manifold publications, and are augmented by various authors some of whom are referenced in this document. [8].

Both science and art rely upon tradition and abstract, intellectual theories to structure their respective activities and make sense of that activity. With science it would appear, on the surface, that matters are more clear-cut, for we have what is named the 'scientific method' that includes experiments designed to validate theoretical assumptions – this does not, again on the surface, appear to be the case with the Arts, or at least this is a commonly held opinion. In scientific postulations of the nature of the universe there is an exclusive reliance upon the intellect and logic to formulate conclusions. As hinted above this has

across directly, people feel that that is horrific. Because, if you say something very directly to somebody, they're sometimes offended, although it is a fact. Because people tend to be offended by facts, or what used to be called the truth." 3.

Thus Bacon desired to represent the existential facts unreservedly and completely, and that because of a viewer's, or critic's, particular mind-set and 'conditioning' this was found to be 'horrific' or 'violent', something that might not possibly occur to a person of a different cultural background, a Japanese person let us say, to them it might be an interesting representation of how things are.

Gilles Deleuze tackles this issue of a graphic representation of violence head-on right at the start of his book "Francis Bacon: The Logic of Sensation",

"Francis Bacon's painting is of a very special violence. Bacon, to be sure, often traffics in the violence of a depicted scene: spectacles of horror, crucifixions, prostheses and mutilations, monsters. But these are overly facile detours, detours that the artist himself judges severely and condemns in his work. What directly interests him is a violence that is involved only with color and line: the violence of a sensation (and not of a representation) When Bacon distinguishes between two violence's, that of the spectacle and that of the sensation, and declares that the first must be renounced to reach the second, it is a kind of declaration of faith in life." 4.

This insight by Deleuze based upon Bacon's own admissions brings us to the hub of any meaning that may be attributed to Bacon's images for Bacon's interest is not with the particularity of instances of 'violence', or 'horror', or even 'sexuality' but with those forces, those 'sensations' that are bound up with such situations. Of course it cannot be ignored that these 'sensations' have a particularity, but in the process of reaching these 'invisible' forces - all emotions and sensations are invisible to ordinary vision - Bacon had to resort to a complete pictorial re-evaluation of what it means to depict the human figure. Otherwise one collapses into the narrative and 'story-telling'; that is one starts to read in sequences of cause and effect in the works that relate to events as they occur in everyday life. If Bacon had allowed this to happen we could then accuse him of 'sensationalism', but he did not and strived on every level to prevent this from transpiring.

Deleuze explains this distinction between the 'spectacle' and the 'sensation' as a difference between the figural and the 'Figure', where the figural refers to the attempt to create an isomorphic copy of a human being through a tried and tested formula of pictorial codes - the mimetic - and is that which appears 'realistic' to our ordinary vision, and where, in contrast, the 'Figure' is a dismantling of these codes, after which there is a re-assembling, so as to create that which is analogous to the reality of a human being pictorially - the 'Figure'. The purpose of which, for Bacon, was to lay bare, to make palpable and tangible, the invisible but all-powerful range of emotions a person is capable of experiencing. As Deleuze reminds us this attempt to make visible the invisible has been a concern of painting from the mid 19th. Century up until the present, for instance Cezanne, Van Gogh, and Kandinsky. With the artists so far mentioned this desire was an unquenchable thirst that could not be relinquished until some success was achieved, regardless of whatever form it took. Paul Brunton echoes Deleuze's sentiments when he states of the visual arts that,

"When they fulfil their highest mission, painting and sculpture try to make visible the invisible, unimaginable mystery of pure Spirit."[5].

This is not to say that human distress is irrelevant to Bacon's intentions for what is the significance of the mouth? As Bacon puts it, and this is true anyway, the mouth and how it changes shape reflects a person's inner state of being and Bacon was particularly sensitive to this. So for Bacon the mouth was a visible gateway that could be investigated so as to gain insights into that which is invisible - the emotional state of the person viewed – if you like their soul. Bacon confirmed this in an unedited extract from a film that no longer exists produced in Wheeler's restaurant in 1958 when in conversation with Daniel Farson he stated

"...there was a very interesting thing that Valery said ... that modern artists want the grin without the cat and by that he meant that they want the sensation of life without the boredom of its conveyance ... how can I draw one more veil away from life and present what is called the living sensation more nearly on the nervous system...". [6].

The assertion, within the British tradition, that Bacon's images are of 'questionable taste' (see Frank Whitford and Peter Fuller) ignores the realisation that Beauty in its true essence is 'terrifying', in that it 'violently' disrupts our sensual appreciation of the world and often assumes the form of the 'bizarre' and the 'ugly'. This is important when assessing Bacon's images and his fascination with Greek tragedy, for the 'ugly' and the 'bizarre' should not present any barriers to our approach to his work, as Rudolf Steiner (1861-1925) states

"All genuine art seeks the spirit. Even when an art wishes to represent the ugly, the disagreeable, it is concerned, not with the sensory disagreeable as such, but with the spiritual, which proclaims its nature in the midst of unpleasantness. If the spiritual shines through the ugly, even the ugly becomes beautiful. In art it is upon a relation to the spiritual that beauty depends." [7].

The position of Rudolf Steiner in this interpretation of Francis Bacon's paintings is twofold. Firstly he acts as a primary source to substantiate statements made, regardless as to whether those statements are considered to be controversial or not, and certainly Rudolf Steiner is thought within certain circles to be so. Secondly, and this is more important in the long run, it is made plain that Steiner deployed a particular methodology in his examination of the natural world and that this led to the conclusions that he made concerning the genesis and development of natural phenomena. These results are documented in his manifold publications, and are augmented by various authors some of whom are referenced in this document. [8].

Both science and art rely upon tradition and abstract, intellectual theories to structure their respective activities and make sense of that activity. With science it would appear, on the surface, that matters are more clear-cut, for we have what is named the 'scientific method' that includes experiments designed to validate theoretical assumptions – this does not, again on the surface, appear to be the case with the Arts, or at least this is a commonly held opinion. In scientific postulations of the nature of the universe there is an exclusive reliance upon the intellect and logic to formulate conclusions. As hinted above this has

been deliberately fostered by its proponents as the only reliable method by which we can come to know the world we inhabit, and in this process emotional responses, intuition and other human faculties of a like nature have been systematically purged from the process of scientific enquiry so as to arrive at 'authentic' knowledge. This is how the legend goes and scientific authorities would have us believe that the so-called secondary qualities of a phenomenon such as texture, smell and colour have very little to tell us and are at best a red-herring in the search for knowledge, and this particularly applies to our imaginative capabilities, despite the fact that at points of impasse some individuals involved in scientific enquiry have been inspired by dreams and 'leaps of the imagination'. Although not pursued here one could interpret this attitude as that of a 'Patriarchal' science, whereby all those qualities and abilities outlawed are associable with the Feminine, and although it has been historically necessary for the dominance of the intellect to occur so that freedom could flourish that time is, patently, now past and there needs to be a reappraisal.(A.C.Grayling's book "Towards the Light).

The opposite appears, on the surface, to be the case with the Arts where there seems to be a valorisation of secondary qualities to the detriment of logic and reason. This generally is the common assumption at present, but this was not always how things were in the past, when artistic achievements were considered to embody all that was worthy of our empirical apprehension of the cosmos. However, another human faculty called the Aesthetic clouds such a picture. This ability of human beings to produce that, which is aesthetically pleasing, satisfying and correct, refuses to corralled by either the 'sciences' or the 'arts'. So what is the relationship between the Aesthetic and Logic, for it cannot be denied that that which is aesthetic has a logic and inevitability to it, even if present models, or theories, of Logic cannot adequately describe, or explain, this? If the posturing and propaganda from either side is ignored then it is apparent that the qualities pertinent to science and the arts are synonymous with the qualities ascribed to the left and right-hand hemispheres of the brain respectively. 9. Consequently it then becomes a question as to whether these two hemispheres can function together in a fully conscious holistic manner, and if it is possible for them to do so then what sort of picture emerges of the world that surrounds us?

Revisiting a theme from the Introduction, instrumental to Steiner's exposition and presentation of his ideas is the example of Johan Wolfgang von Goethe (1749—1832). As stated it is now largely forgotten that Goethe had a considerable reputation as scientist within the German society of his day. Goethe's achievement, scientifically, is that he developed a methodology for the exploration of the natural world, in all its diversity, which combined his imaginative and rational faculties. Pertinent to Goethe's methodology was a reliance only upon that which appeared directly to the senses, and importantly not compromising the outcome of his observations by relying upon preconceived theories. Thus Goethe had no time for metaphysical speculations about the nature of matter, or for theories that proposed metaphysical realms outside the ambit of human experience. Goethe was far more concerned with how the phenomena of the natural world developed and reached maturity. For instance, how does a plant develop from a seed into a mature flower, what were the rules that governed this development and what was the nature of the inter-relationship of the parts?

Goethe was no philosopher in the sense of being able to mould his discoveries into a formal theoretical structure of human cognition. Rudolf Steiner had this ability and recognised that latent in Goethe's methodology were all the components for a theory of knowledge. Steiner's methodology places the human being's cognitive capacity at the centre of the struggle for 'knowledge', and not abstract theories or presuppositions. The import of this approach is that it enables an individual to verify any conceptualisations and postulations concerning the 'natural world' for themselves through the development of their own cognitive capacities, this is not possible at present for specific scientific postulations – no individual can verify the atomic theory of matter for themselves, as no-one has seen an electron, proton etc– it has either to be accepted upon 'authority' or is taken as truth because the individual finds it reasonable. This is not the case with Steiner's or Goethe's methodology for a person can go out into nature and observe for themselves whether or not there is any validity to Goethe's statements concerning the metamorphosis of plants. Admittedly, to start with this is no easy task for this way of thinking is so unfamiliar. However crucial to both Goethe's research and Steiner's refinement of Goethe's research is that their approach draws the human being into the creative universe and does not perpetuate the division between humanity and nature (dualism), which unfortunately is a side-effect of abstract theories regardless of whether they are 'true' or not. 10. This is the essential aspect of Rudolf Steiner's work that will be utilised in the following text. The points outlined here will be further referred to, and developed throughout this text, but it has to understood that any statements made derive from the methodology as proposed above, and that the value of 'controversial' propositions has a direct link to one's familiarity with the methodology involved, just as the seemingly strange statements concerning the nature of the universe that issue from the scientific community rely upon one's familiarity with current scientific methodologies and theories.

Frank Furedi (Professor of Sociology at Kent University, Canterbury) in his book "Therapy Culture" provides an incisive and detailed account, from an academic perspective, of how through counselling and other therapies there has occurred an heightened awareness, over the past 30 yrs., of the need to be more mindful of our emotional well-being. Whatever one's opinion with regard to these therapies their prevalence indicates a wide-spread realisation of the central position emotions occupy with respect to our general health. This being the case most people will have no difficulty recognising the absolute reality of our passions, desires and emotions even if they are invisible to ordinary vision, and the same could be argued of the Ego. It is also acceptable to state that even if the ego and the emotions cannot be recognised as separate realms in themselves that permeate the whole of nature they do make themselves visible by manifesting themselves through our individuality. Difficulties of reception for some individuals will be compounded by the assertion that there is another realm of forces that work alongside and within the realms of the emotions and the ego that has been designated as Formative forces. As indicated above these forces are responsible for the growth and development of all that exists, and the epistemological paradox of the existence of 'pure' concepts that have no percept directly impinges upon this text. For empirical, scientific methodologies depend upon thinking about percepts (or directly perceived phenomena), so as to ascertain what constitutes the world. The impact of this paradox becomes evident when we consider emotions, like anger or jealousy, which have

been traditionally associated with colours, for although we may say that this association is merely symbolic this is not good enough if we take empiricism seriously. If we have a concept for which there is no percept then the conclusion can only be that knowledge is incomplete until the time that the percept becomes visible. Taking the other side of this paradox, is it possible that we are amongst many percepts that are perceived but cannot register in consciousness because there is the lack of an adequate conceptual framework from which they can be cognised?

Projective geometry provides the structure from which it is possible to build such a conceptual framework, and where the most propitious place to observe the working of Formative forces through growth is not the human being, because of its complexity, but through observation of the plant kingdom. All three of the realms outlined above are governed by a common set of principles, or Laws, (which will be elucidated later), that are distinct from the Laws of the physical world, and just as we are able to conceptualise the functioning of the physical world through Cartesian Space-Time Continuum, so we are able to conceptualise the above three realms, particularly that of Formative forces, through the mathematics of Projective geometry and a different type of space. 11. So the validity of the arguments presented here do not ultimately rest upon the value of personal testament or the power of philosophical reasoning, but upon the authority of Mathematics. However the mathematics referred to, that of Projective Geometry and its usefulness in comprehending significant sections of human cognition, is not widely known, and will therefore be unfamiliar to many readers. The mathematics that we are mainly familiar with that underpins the Cartesian Space-Time Continuum is ideally suited to computing the inorganic aspect of the world we inhabit but gives us very little understanding as to how our soul and spirit function. An example being that of Beauty, it is absurd to attempt to quantify Beauty, for it simply cannot be weighed or measured. However it can be understood in terms of *intensity* and *polarity* and these are concepts central to Projective Geometry. Thus it is not a question of stressing one side more favourably than the other – that all is material or that all is spiritual - for everything that we are aware of that is living is a sublime interaction of the spiritual and material, and each realm has to approached by the mathematical model suitable for it.

If it is possible to perceive the above realms in themselves the question becomes how is this achieved ? The answer to this question is through sense organs capable of doing so, at present this latent capacity lies dormant in the sensory organs already possessed, and there are two possibilities for acquiring this latent capacity. Firstly by birth (a person is born with the natural ability to perceive these realms), and secondly through training by practising specific exercises designed to have such an effect. In essence this is no different from an athlete developing aspects of their physical body and spatial co-ordination and awareness, the effect of which is astounding for someone who has not undergone such training, so is there any reason as to why this cannot be achieved with our sensory organs, which are, after all, part of the physical body? Alternatively the corporeal body could be viewed as insulating us from the full force of sensory impressions, i.e. the absolute effect of all that is sensory is suppressed by the density of our corporeality. Then the above exercises would, so to speak, cause the intensity of sensory sensations to be turned up whilst the dampening effect of the body is lessened. There have been many artists who have been so endowed – the poet William Wordsworth by birth and Wassily Kandinsky partially through training.

The intention with this interpretation is not just to re-evaluate the significance of Bacon's *oeuvre* but to rehabilitate the value placed upon artistic cognition. This is necessary for if the epistemological downgrading of an artist's cognitive powers, first postulated by Emmanuel Kant (1724-1804), for the determination of 'truth' is persisted with then the result would be the continuation of an attitude that with respect to so-called 'hard' facts that the Arts have only an 'entertainment' value. It is scientifically recognised that the human being cognises from sensory organs that are only capable of registering a narrow band of all the possibilities available to them in there 'normal' state, to take one example night-vision goggles have been developed so that a person is able to perceive infra-red emissions imperceptible to normal vision. Furthermore the full potential of the organs we have is not recognised or commonly used, and this is demonstrated by how particular animals greatly enhance the organs they possess, such as sight with birds of prey and sound with bats. Nevertheless it is also recognised that artists and musicians also enhance vision and hearing to a limited degree, in comparison to these animals, through their specialisations and natural abilities, but is this the limit to the development possible produced by following these vocations? This is an open question because there has only been rudimentary research in how our sensory organs have evolved and are evolving, and where such information that exists and finds its way into the mainstream is partial and inadequate. The use of any technical device distorts how our sensory organs are appraised by seeming to add, miraculously, to our normal capacities – who is to say what would be perceived by a person who had developed their visual capacities to register the infra-red spectrum!

What can be said is that it would be very different than that known through wearing night-vision goggles, just as when viewing a scene for the first time that was only known through a photograph we realise the paucity and bias of the information given by a camera. When considering contentions concerning 'invisible' realms that are only partially cognised such as the emotional realm and growth it must be taken into account that in the physical world, through the course of history, there has been an investigation of 'invisible' forces that are only partially cognised, and two very good examples are electricity and magnetism. Further consideration of these two realms reveals that fundamentally they function through a polarity, and it is possible to apply other elements implicit to Projective geometry thereby facilitating further investigation into their potential. Returning to my subject-matter, so far there has been no serious attempt to devise a framework within which to 'scientifically' evaluate that which flows from artistic creativity, hence my proposals concerning Projective Geometry. This is of vital importance for it would be folly to regard an *essential* dimension of the human being as inferior to its rational and intellectual abilities to think abstractly in view of the problems faced in every area of human activity.

The contention is that Bacon is one of those individuals who, like Wordsworth, was born with the natural ability to perceive the realms under discussion and that he was an 'unconscious initiate', a phrase that Steiner used to describe Goethe. The difference with Bacon is that he was clairvoyant but not an initiate, whereby the latter knows the names and functioning of that perceived whilst the former does not, and this constitutes one explanation for the chaotic appearance of Bacon's paintings. Steiner named Goethe an unconscious initiate because although he was naturally endowed with clairvoyant capacities it is only through his own efforts that he came to understand what he perceived clairvoyantly and not through

a formal training. Bacon did not attempt in any way to intellectually comprehend what he saw, but rather worked as a true empiricist by recording unequivocally that which he perceived, and from his point-of-view focussing exclusively upon the effect of the Astral body upon corporeality. Is there any evidence to validate these assertions? Within the scientific community there is a long history of conducting experiments to test the veracity of the statements of individuals who claim to have extra-sensory abilities (clairvoyance, telekinesis, prayer, remote viewing and many more). Whilst the results have been inconclusive with respect to individuals this is not the case when humanity *in toto* is considered. It cannot be stressed enough how important Dean Radin's research (referenced above) is in this respect, for Radin is not what might be referred to as a knowledgeable lay-man but lies at the heart of American Academia, as any superficial perusal of his pedigree will reveal. This text will attempt to validate the above assertions by theorising from well-known facts that are part and parcel of everyday experience. By demonstrating how there is an equivalence between Bacon's images and what is known of the 'invisible' realms referred to above there is a validation of the power of the language of art for epistemological purposes. Meaning that when Bacon's artistic language is deciphered it is shown to refer to concepts discovered by individuals who also had the ability to perceive the realms under discussion, but which have been, in Bacon's case, concealed by present prejudices regarding the potential of artistic cognition. Through this strategy the reader will be led through a series of steps that indicates that Bacon's primary concern, when painting, was with the affects and effects of the Emotional realm, and that Bacon believed that it was absolutely essential that human beings understood how these forces functioned, otherwise they were in danger of being swamped, thereby compromising their evolution, by the powerful and devastating forces that issue from this realm.

Notes.

1. Russell, 1972: 11, 26, 73. By extension Russell views Bacon's images in terms of conditions of life in totalitarian states.

2. Sylvester, 1987: 22-23.

3. " " " : 34-35, 48-50.

4. Deleuze, 2004: x.

5. Steiner quoted in Fitzgerald: 114

6. Farson, D. 115-117.

7. Brunton,1987: 21.

8. Rudolf Steiner (1861 - 1925) was an Austrian philosopher whose ideas have had a considerable impact upon Epistemology in Europe, particularly Germany. In 1924 he founded the General Anthroposophical Society and within the Anthroposophical movement his mode of cognising nature is now known as 'Spiritual Science'.

9. See Betty Edwards. Drawing on the Right Side of the Brain.

10. See Henri Bortoft. The Wholeness of Nature. Goethe's Way of Science.

11. In their book The Plant between Heaven and Earth.Georg Adams and Olive Whicher provide a comprehensive account of how we are able to perceive the activity of Formative forces in the plant kingdom, and how these forces conform to the tenets of Projective geometry.

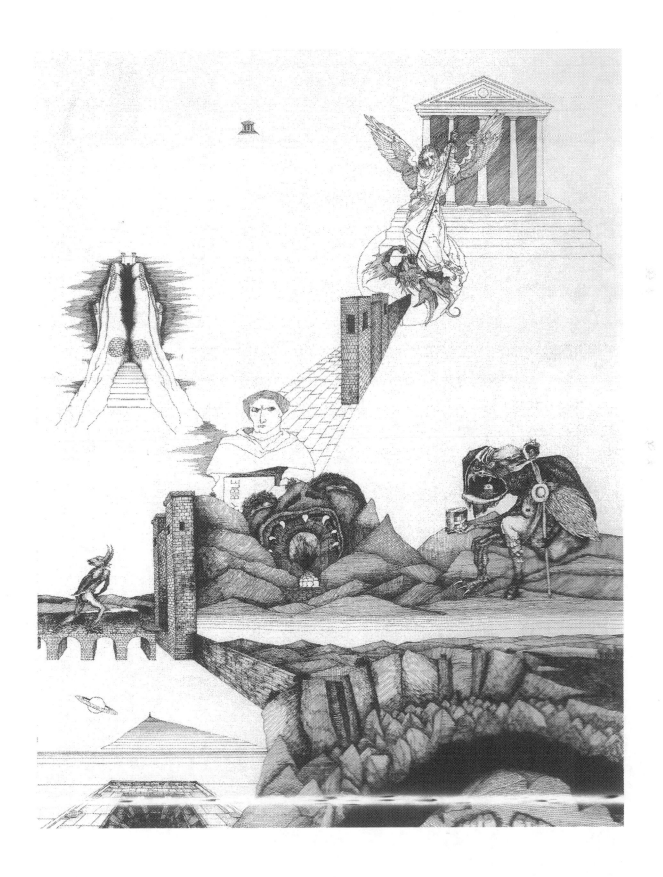

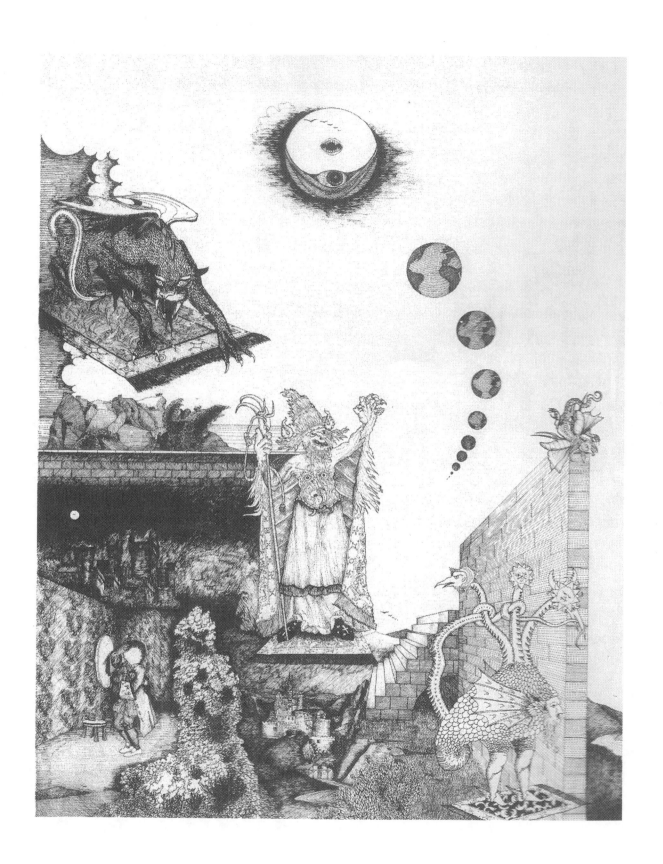

Chapter 2.
Impossible Simultaneity and Projective Geometry.

After overcoming the emotional disturbance that results from a first viewing of Bacon's paintings it is more than likely that one notices the movement, or more specifically the change and metamorphosis, of the Figures. In reply to M. Archimbaud's question "Do you like Gericault?" Bacon states

"Yes. The impressive thing about Gericault is the sense of movement in everything. Especially the representation of the human body and of horses; everything is captured in an incredible sense of movement. But when I talk about movement, I don't mean the representation of speed, that's not what it's about at all. Gericault somehow had movement pinned to the body. He was fascinated by it."[1]

There is when viewing Bacon's Figures the feeling that although they have an energetic quality to them this is being expressed in a way that is hard to comprehend. We normally perceive movement as the rate of change of a body within three-dimensional space – Cartesian space. The element of speed (rate of change) has a dramatic and stirring impact upon our consciousness, and evokes within us a wide range of emotions and sensations. Yet Bacon is adamant that this is not what he is talking about and, further, that Gericault's images capture the quality he is referring to. The only clue we have is Bacon's enigmatic phrase that 'Gericault somehow had movement pinned to the body'. By denying the concept of speed Bacon is implying that it is not dynamic, linear, mechanical movement that concerns him, but rather that he has perceived, and is concerned with depicting, some other type of movement that is intrinsic to the body, and it can be appreciated how radically different Bacon's depiction of movement is when it is compared with, for example, how motion is depicted by the Futurists.

Bacon's attempt to capture in his Figuration a movement, or dynamism, of the body that is very different from that which is linear and mechanical is emphasised in a conversation with Michel Archimbaud.

M.A. "Nevertheless, the analysis of movement through photography has been very helpful to painters, such as Degas, hasn't it? For example, in studying the way horses gallop?"

F.B. "Yes, but not for me...". 2.

From this it is understood that the reason that Bacon was interested in photography –examples of Muybridge's photography are known to have been in his studio – was not for information concerning mechanical movement. This creates a problem for in the course of everyday life we are only normally aware of movement as mechanical and linear. Daniel Kurjakovic (an Art Historian who has published various articles in a number of publications) presents an important insight into the triptych "Three Portraits: Posthumous Portrait of G. Dyer, Self-Portrait and Portrait of L. Freud", 1973, (ill. 1), of which he says that the triptych's space is not 'expressly three-dimensional', and that the relationship of the Figures is marked by their being on a different axis to that of the background. This Kurjakovic believes allows them to perform an 'impossible simultaneity' where they can hypothetically substitute for each other. Kurjakovic's insight is thus suggesting that Bacon's Figuration records that which we consider to be impossible for our ordinary consciousness, namely that individuals are not separated out from each other discreetly in space and time, but that they have a commonality in that they can, from a particular viewpoint, be perceived as inhabiting, or dwelling within, in some manner, one common space. Naturally from a corporeal viewpoint we are discrete bodies in space, but this is not the case spiritually and from that viewpoint we exist in simultaneity with all beings. Clearly such an insight implies that we have to reconsider our normal understanding of the Cartesian space-time continuum when viewing Bacon's images. Kurjakovic in the rest of his commentary states that we can only really understand Bacon's work if we take into account Bacon's disruption of Classical perspective; where Classical perspective is the technical means developed, by artists, for the pictorial rendition of objects in what we call the Cartesian space-time continuum. Additionally Kurjakovic is implying that this was so important to Bacon that Bacon went to the lengths of producing a triptych that not only expressed the connections he perceived, but that in so doing he felt it necessary to subvert common assumptions as to how we perceive and relate to others in everyday space. 3.

Gilles Deleuze notices a correspondence between Bacon's use of line and that of the line in Gothic Art. In Gothic Art although the line traces out organic forms it escapes this functional subordination through the decorative (as opposed to the ornamental), the patterns and interactions produced by the interaction of the lines aesthetically affect our sensibilities so that we are drawn away from the portrayal of objects in space into realms that are generative of the real-life organic forms depicted. This is what Deleuze states, and the uplifting effect of the Gothic is well-known and documented. Deleuze then goes on to argue, and this will be re-visited later, that with the evolution of the optical-tactile space of Classical perspective, that the line became subjected, as a contour, to the codes for depicting objects in everyday space and that in order to achieve his aims Bacon, and this also applies to a great number of other artists, had to prise the line away from such a utilitarian function.

" ...it is not by outlining a form, but on the contrary by imposing, through its clarity and nonorganic precision, a zone where forms become indiscernible. It also attests to a high

spirituality, since what leads it to seek the elementary forces beyond the organic is a spiritual will. But this spirituality is a spirituality of the body, the spirit of the body itself, the body without organs........ (The Figure of Bacon would be that of the Gothic decorator)". 4.

Deleuze understood the 'line' in Bacon's paintings to be a 'spiritual' line, in that it raised awareness from the organic form depicted to forces generative of the organic:

" lines of flight that pass through bodies, but which find their consistency elsewhere lines that are 'more' than lines, surfaces that are 'more' than surfaces It is out of chaos that the 'stubborn geometry' or 'geological' lines first emerge this frenetic line: it is a life, but the most bizarre and intense kind of life, a *nonorganic* vitality" 5.

From this it is apparent that Deleuze, and Bacon by default, spoke of and depicted 'lines' other than as they are understood through Euclidean geometry. Deleuze struggles to find words descriptive of these other lines, and his 'stubborn geometry' is an elusive concept. As far as it is known neither Deleuze nor Bacon were aware of the existence of Projective geometry, but Deleuze's above description of lines and geometry bear a similarity to Steiner's statements

" One receives an 'imagination' of the whole cosmos, One receives a counter-image of the three geometrical space dimensions. What one receives can take a variety of shapes One receives the idea of space which I can only indicate figuratively. If I indicate the ordinary space by three lines at right-angles to one another, I should indicate this space by drawing everywhere sets of figures or configurations, as if surface-forces, or forces in surfaces were approaching the earth from without, from all directions of the universe, and were working plastically on the forms upon its surface". 6.

"...these mutually supporting forces in space were recognised as they streamed hither and thither. They were felt and perceived by those in whose soul the idea of the Greek temple arose. They did not 'think out' the forms, but they could perceive the force streaming through space and then worked the stone accordingly...Thus the Greek temple is a material representation of forces working in space. Such a temple is a crystallised percept of space, in the purest sense." 7.

Deleuze proposed that with Bacon's Figuration, specifically here with how line is deployed, there is a movement away from merely registering the materiality of the flesh and bones of our physical bodies in search of those fundamental forces that give rise to our flesh and bones. This is an absolutely crucial insight and its ramifications will echo throughout this text, for a line is capable of expressing more than the outline of a form. Proclus, a fifth century A.D. Neoplatonic philosopher, gives an idea of this power of line when he describes his experience of the *ars lineandi*:

"*Ars Lineandi* is the recaptured memory of the invisible ideas of the soul: it gives life to its own cognition, awakens the spirit, purifies understanding, and brings the formative element, which is part of our being, to light. It eliminates the baseness and ignorance that clings to us from birth, and liberates from the bond of unreason. It rouses the soul from sleep and impels it towards the spirit. It makes us a true human being, allows us to behold the spirit and guides us towards the gods." 8.

Steiner's description of a temple as being 'a crystallised percept of space' is an apt analogy for some of Bacon's images, and Proclus' comment of bringing 'the formative, which is part of our being, to light' further illuminates Steiner's comments above. The statement by Proclus also serves to remind us that with our coming-into-earthly life at birth our consciousness, after the first years of infancy, suffers a 'forgetfulness' of its relationship to the light-filled higher members of our being (body of formative forces, soul and spirit) and the Cosmos. During these early years, which end with our learning to speak and think with an earthly language, we are in absolute, undivided communion with the Cosmos. The *Ars Lineandi* according to Proclus is a way of resuscitating this lost memory so as to regain our humanity. It is also apparent that Deleuze was aware of such 'invisible ideas of the soul' as described by Proclus, and that these could be expressed through lines, and that with Francis Bacon he recognised another individual who had the same ability. However it still remains to indicate how this concept of 'lines in space' can be approached from everyday experience. A particularly good example is with the fields of electro-magnetic force and sound. It is well-known that it is possible to make these invisible force fields perceptible through the use of iron filings which reveal the patterns of these forces in space. We never see the 'lines of force' of these fields but they are nevertheless present permeating the space surrounding us in our daily lives. These, however, are mechanical force fields and as such are related to the inorganic world, whereas the focus here is with those forces that are related to the organic living world, and it has to be clearly stated that they are of a completely different order to mechanical forces and consequently make themselves manifest through an entirely dissimilar manner.

Heaven's Geometry.

Through the development of Euclidian geometry we have now become such masters of the spatial world of our waking consciousness that we are able to send men to the moon. But at the same time that Rene Descartes, (1596-1650), put forward his brilliant mathematical insights that eventually made such a feat possible Girard Desargues, (1593-1662), pursued a different and equally brilliant line of mathematical enquiry into what is known as Projective geometry. Euclid's theorems and Descartes' mathematics concern the inorganic and earthly dimension of the world that we inhabit, and how we can measure this and predict movements within it. The Cartesian Space-Time Continuum has been developed as a model so that we can orientate ourselves within, and negotiate, the world of wide-awake ordinary consciousness. This is the inorganic world of matter that we cognise, whilst awake, through the auspices of a mineral, corporeal body. The Law of Cause and Effect, which orders the course of events, and the force of Gravity are primary to this world of matter. We perceive how through the force of gravity matter interacts and masses are built up through a process of accretion or how masses are worn away either through collisions or through the effect of mechanical forces.

This is one side of our consciousness, but as we are all aware we do not spend all our time awake but have periods of sleep during which we dream and have spatial experiences that are contrary to those of being awake. There are experiences of floating and flying; there are also experiences to be had where one event seamlessly transforms itself into something completely different. Experiences of time are also contrary to everyday expectations, events can interrelate to each other and appear natural, which on waking-up we realise relate to different periods of our lives. Past, present and future interact in a different manner during sleep than the linearity of waking consciousness. In addition we have little or no awareness of ourselves as an entity that is comparable to that we have of being conscious in our physical bodies. We do not normally feel any of the solidity of being we experience whilst awake when dreaming, in fact we might find ourselves expressing different personality traits in different situations, some of which we may find distressing when awake. Was that I or was it someone else that felt like me doing and enjoying those things? When dreaming we lose our centeredness, for our being and identity is spread out over many various dream scenarios, and we may well ask upon waking up how do I know that it is the same person who has woken who went to sleep? The answer to this question is given by the fact that we wake up to the *same social and physical conditions that existed upon going to sleep and an ego-consciousness of those facts*. This seems self-evident for it is through possessing an ego that I know that I am I, and it is only through our ego-consciousness coming up against the non-ego of the outer world that we have a sense of self at all.

Our waking experiences of space are distinguished from those of sleeping by the fact that, in general, it is not possible to become fully self-conscious during sleep. It is now known that there are three phases of sleeping activity: the dreaming upon going to sleep, deep-sleep dreaming of which we have no consciousness and dreaming upon waking up. From another perspective, and this is one example of many, the simultaneity sometimes experienced during dreaming is to found during waking consciousness. Whilst awake we know that if we look at the night-time sky we perceive the whole panorama of the stars through the

small amount of light that enters our eyes, and this is true of everyone. From this we can say there exists within the fragment of light we perceive the totality of *all* light, and this is even more true of daylight when there is a single source of light from the Sun. Meaning that we are *simultaneously* connected to everyone whilst awake, or contemplating the stars, through the medium of the light. Even from this basic example, which can be extended endlessly through commentary upon holograms and the like, it is realised that simultaneity is an important but hidden and largely ignored aspect of our cognition. It is not suggested that this is the only explanation of the simultaneity that Kurjakovic perceived in Bacon's triptych, but it is indicative of levels of consciousness where simultaneity of being is possible outside the corporeal body within the psychic dimension of existence.

These observations have a direct relationship to Bacon's iconography for, as will be referred to below and throughout the rest of this text, Bacon explored the juxtaposition of waking consciousness and sleeping in daily existence and it's meaning for us existentially. Observation of "Painting, 1946", (ill. 2) reveals that the central Figure has its physical eyes occluded thus indicating that the Figure is 'sleeping', also observation of "Triptych Inspired by the Oresteia of Aeschylus", 1981, (ill. 3) reveals what can only be described as weird Figures performing bizarre acts of will, and where once again the Figures have occluded sight even though they have a purposefulness. The import of these 'sleeping' apparently wakeful Figures is that they seem to be able to be sleeping and wakeful simultaneously. So if it were possible for everyone to be as self-conscious during sleep as when awake, particularly of the middle part, deep-sleep, of which there is *no* consciousness, what would we experience? One immediate consequence would be that such an individual would have consciousness of the space relevant to each state, and there are individuals who claim to be able to invoke this ability at will. Accordingly we have much first-hand information concerning the state of being fully conscious during deep-sleep (lucid dreaming), and one particularly noteworthy example is quoted below. The question then becomes whether there is any system of thinking that can convey these experiences that has an objective validity outside that of personal testament?

The postulations of Projective geometry are such that they theorise about properties of simultaneity, inter-relatedness, metamorphosis, floating and non-linear time sequences, and in this sense connect us symbolically with the experience of dreaming. However the intention is not to fully outline the features of Projective geometry immediately, that would not be feasible but an in-depth exposition is to be found in Olive Whicher's books "Sunspace" and "Projective Geometry". As Whicher explains

"Projective geometry is not merely a geometry of created forms, but the geometry of the relationships between form-creating entities." 9.

Whicher also draws attention to the fact that Projective geometry theorises from the plane-at-infinity to the point, whereas Cartesian geometry does the opposite theorising from the point to the plane-at-infinity. The practical value of Cartesian geometry, and its associated mathematical models, is that it enables us to understand how the force of gravity and other mechanical forces radiate out, and operate, from points in the world of matter with which we are so familiar. Thus to have any practical value Projective geometry has also to provide

a similar service, i.e. it has to indicate to which phenomena in the world its tenets are applicable for waking consciousness. It is Steiner who provided the insight that it is with the organic world, with that which is living, that such an endeavour should start. He also indicated that the forces associated with the plane at infinity were formative, moulding forces that worked from this plane, in a hovering, floating manner, through the force of levity to create the living. To claim that there is a force, named levity, that is equal and opposite to gravity will no doubt be greeted by some with incredulity, my own particular journey started out thus, and as a side-line to this issue there are those that seriously (present evidence) believe that the universe is expanding ceaselessly (levity). My suspicions started with the question why do things expand and rise through heat? The usual explanations that 'atoms' get excited together with more sophisticated reasons, were unconvincing including those that theorise from energy levels or states. Anyway I have no intention to mount a defence for this claim and I direct the reader to Ernst Lehrs book "Man or Matter" for a discussion based on scientific principles, especially when considered objectively there is no reason for there *not* being a force equal and opposite to gravity within the bi-polar universe of our experience. 10. Further discussion of the effects of levity, which is the primary force of the space of Formative Forces, is to be found in Georg Adams' and Olive Whicher's book "The Plant between Sun and Earth" and even the most cursory of glances will indicate that their research is based upon sound reasoning and evidence. Concepts such as those discussed above considered to be real but which have no percept must exist somewhere, so where does their reality lie, what do they consist of and what forces are pertinent to how they function? Clearly they do not exist in some metaphysical realm apart from the material, inorganic world we inhabit for we live and work with these concepts *within* this world in an uncomplicated manner; all that can be said at this point is that there is a 'hidden-ness' to our everyday cognition of nature - a part that does not fully reveal itself to ordinary consciousness.

When we look at a living organism what we perceive is the interaction of two sets of forces, those that are orientated towards Levity and those orientated towards Gravity, where the Formative forces, emanating from the plane at infinity of ethereal space, penetrate into the gravity-bound matter of the material world so as to create that which lives. We bear witness when we look upon, let us say a plant, the interaction of the two spaces described by Projective and Cartesian geometry respectively. Initially familiarisation with Projective geometry's principles and their relationship to Formative forces and the life forms of nature erodes the picture of nature as a collection of separate phenomena standing side-by-side that are mechanically related. Instead it is felt, and perceived, how nature is an inter-related whole where particular forms that appear in lower life forms appear again, but transformed, in higher life forms.

Lemniscatory Space.

An abstract appreciation of how these two spaces (the earthly and the heavenly) interact in any living organism, is gained through the Lemniscate (ill. 4), which illustrates the cross-over point of Lemniscatory space (Cartesian space interacting with the Ethereal space of Formative forces described by Projective geometry). As can be seen this is a fascinating figure for if one traces a route from the inside of a line on one side then one emerges on the surface of this line on the other side, properties that are enhanced by viewing the Lemniscate in three-dimensions. This figure gives a feeling for moving in and out of spaces and is of immediate importance in attempting to understand Bacon's Figuration, and so it is worthwhile exploring how Bacon displayed in his works an innate, intuitive understanding of the cross-over point of Lemniscatory space.

To initiate this discussion attention is drawn to those illustrations that have a curiosity value because of their reversibility, Gestalt figures. (Examples of Gestalt figures, the Lemniscate and Bacon's images are to be found on my website Artskape.co.uk). Here we have figures that display within a single form the possibility of being interpreted in two different ways, and so we have two contradictory readings that co-exist within our consciousness *simultaneously* in the same form, only one of which can be seen at any particular moment. There has to be a movement in conscious cognition away from one to the other whereby all the parameters that condition one interpretation are rejected in favour of the other. In other words our thinking has to turn itself inside-out whilst the figure remains unchanged. Although these figures give an impression of the cross-over point of Lemniscatory space it has to be remembered that the above is static, whereas with Projective geometry and Formative forces all is movement and change. To normal obseration a plant is a static organism (even if in an abstract, intellectual manner we know it is not), however as implied this is not its true nature for a growing plant is always undergoing transformations, as when it is producing flowers, fruit or seeds. The only time a plant approaches something like being stationary is during the winter for during this time the Formative forces have retreated and the seeds and buds lie dormant awaiting the return of the sun in the spring.

A viewing of Bacon's images reveals that from the start of his career he embedded his Figures within cube-like structures, particularly in the 1950's, but the striking feature of these structures is that they rarely make sense as objects typical of Cartesian space, for they are impossible shapes. "Three Studies of Lucien Freud", 1968-69, (ill. 5) is a particularly refined example of a Figure embedded in a cage-like structure. This triptych displays from the viewpoint of 'focalisation', where focalisation refers to spot where the viewer's vision is focused in an artwork, an unusual characteristic. In traditional Western perspective there may be any number of vanishing points in a work, but there is usually only one dominant point to which attention is directed in accordance with the action of the work in question. This is not the case with this particular triptych, for the viewer's attention is split between the panels. In this triptych "Three Studies of Lucien Freud", we see that the tubular framework that surrounds the figures divides the head completely in the outer panels whereas it only partially does so in the central panel. Therefore we have only one complete head that has a damaged, or divided, head on either side of it. The properties of simultaneity and lack of focalisation are emphasised in this triptych through the fact that the outer left and right parts

of the head in the two outer panels can be joined, imaginatively, to form a full face that may, or may not be that of the central panel, likewise we can speculate as to whether the inner right and left of these two panel's divided heads are in fact mirror-images of each other. In deciphering this deceptively complex triptych it is useful to bear in mind the exercise one can perform with a mirror , whereby one stands in front of a mirror and holds up a mirror in front of one half of the face so that one half of the face is reflected in the mirror thus creating an imaginary whole face from one half, and repeating with the opposite half– the result of which is astonishing with respect to how we usually envisage ourselves. So although there is no particular spot to which the viewer's attention is drawn in this triptych nevertheless focalisation is implicit to this work, but on an *imaginative* level, having been stretched over the three panels to emphasise the work's simultaneity.

By doing this Bacon is able to incorporate into one work differing viewpoints of Freud and thereby depict, in the triptych as a whole, what he believed to be a fundamental note of Freud's character at that time. There is with this work an almost crystalline atmosphere as if Bacon was attempting to construct a magical lens through which he could adequately focus upon a subject that was always just beyond his grasp. Bacon has with this work completely revised Western portraiture away from the subject's vanity and a concern for representational technique whilst retaining the psychological depth that constitutes a worthwhile portrait. In constructing this frame Bacon 'pinned down' the movement between all the possible interpretations of his subject. Bacon attempted with this triptych to record the differing emotional conditions of Lucien Freud some of which, as with any individual can be diametrically opposed, and in this sense we experience something of the movement from one reading to another typical of the reversible Gestalt figures referred to above.

This creates a tension between a coming and going of something from some unknown point, or place, and by doing this Bacon has imbued the whole of this triptych with a definite rhythmic quality that augments the emotional turbulence of the figure. Our normal experience of Cartesian space is that it is, typically, a colourless, seemingly empty medium in which we find objects or phenomena, inorganic and organic, in varying degrees of solidity. However Bacon has in the above triptych rendered space palpable and made it integral to the depiction of Freud, and indicated, through the use of frames, that space is permeated and activated by the invisible forces of emotions, a fact that is particularly noticeable around the human being. Consequently my experience as a viewer is that the space in Bacon triptychs is not merely a subsidiary medium in which objects are located, but is alive and plastic. The assumption of everyday, ordinary consciousness is that instincts and drives together with their associated sensations are not visible to the naked eye, but is this the whole truth of our experience? If animals are considered as being the pure and unsullied expression of specific sets of drives and instincts it can be said that instincts and drives are obliquely observed through the particularity of animals. This normally eludes experience for it is not common to evaluate phenomena from such an angle. The crucial point here, and this cannot be repeated enough, is that these realms which are spoken of are not separate from everyday space – a separate metaphysical dimension – but are thoroughly entwined within ordinary, Cartesian space. Bacon makes this understanding explicit by surrounding his Figures with 'tubular constructions' that are rooted in ordinary, Cartesian spaces, such as rooms.

The primary signifier that Bacon's frames, or 'tubular constructions', relate to a space other than that of Cartesian space is the fact that they are impossible shapes – they do not cohere as Cartesian three-dimensional objects. So the conclusion is drawn that these frames mediate between the two types of space that Bacon was aware of, that is they depict the point where forces move from one type of space to another, and within Projective geometry this is the cross-over point of Lemniscatory space.

A Spiritualised Pictorial Space.

Through this scrutiny of the above triptych it has been provisionally established that Bacon was aware of two types of space; one related to the inorganic world the other to the organic world. It has been proposed that the reason Bacon embedded his Figures within geometric structures was that this was a technical device to represent how forces move from one type of space to another, meaning that these geometric frames relate to the cross-over point of Lemniscatory space. This assertion is validated through a further consideration of how Bacon integrated these two types of space within "Three Portraits: Posthumous Portrait of G. Dyer, Self-Portrait and Portrait of L. Freud" and "Three Studies of Lucien Freud". Both of these works show Figures in rooms. In the former work it is three different Figures whilst in the latter it is three different versions of the same Figure. In "Three Portraits: Posthumous Portrait of G. Dyer, Self-Portrait and Portrait of L. Freud" there are no tubular frames, however as Kurjakovic noted, the Figures exist on an axis separate from that of the room, which represents ordinary everyday space, and possess a simultaneity. These Figures also have a 'sameness' to them in how they have been executed, for each one of them appears to be emanating from its shadow. But these shadows only loosely reflect the seated Figure, and give the impression that they are voids within the fabric of the three-dimensional space of the room. The overall impact given is that the Figures appear to have emerged from some other dimension. By constructing this triptych in this manner Bacon has depicted the separateness characteristic of the material world in conjunction with the simultaneity characteristic of our spiritual being – simultaneously. In addition it cannot be ignored that this is a posthumous portrait of Dyer, (Bacon produced several posthumous images of George Dyer and they strike one as odd for practically all of them show Dyer performing actions of the living and seemingly having interaction with the living), perhaps Bacon was implying by depicting Dyer in this way that the connection between the living and the dead in formative space is one of continuity, connection and simultaneity! 11.

So why are there no tubular frames in "Three Portraits: Posthumous Portrait of G. Dyer, Self-Portrait and Portrait of L. Freud"? Examining why there are geometric frames surrounding Lucien Freud in "Three Studies of Lucien Freud" provides one answer to this question. In this triptych Bacon was attempting to depict Freud trying to cope with the onslaught of various emotional states and forces. There is a triptych that has precisely the same theme, but without the geometric frames and that is "Three Studies for Portrait of Lucien Freud", 1966, (ill. 6). In this work we merely have a Figure uneasily writhing on a bed of some kind, and what could be three moments in a linear sequence of events. There is a 'looseness', a sort of irresolution, to this work that lessens its impact upon the viewer. With "Three Studies of Lucien Freud" the geometric frames give cohesion to the triptych and by their construction indicate that the emotional forces afflicting Freud not only have a common source but do not correspond to linear time sequences alone. The geometric structures around Freud make it plain that Bacon's concern was with attempting to depict how emotions rise and fall with particular intensities. Thus the geometric frames serve as mediators between the invisible realms of emotions and the visible realm of substances, and as such are metaphors for the cross-over point of lemniscatory space as outlined above.

So the essential difference between "Three Portraits: Posthumous Portrait of G. Dyer, Self-

Portrait and Portrait of L. Freud" and "Three Studies of Lucien Freud" is that the former relates to a social situation, and as such required a different treatment to the latter that deals with an individual's private feelings, otherwise the use of a geometric frame would have become meaningless as an artistic device, degenerating into just an affectation or stylistic convention. However Bacon attempted to go further than this and definitively depict how the human being is an amalgamation of both these types of space and their associated forces, this is why we have Figures, painted principally from the viewpoint of solid bodies in space, ensconced within the geometric frames and other Figures that appear to be dissolving outwards. The impression given is that Bacon was attempting to represent how through being alive we bring these two spaces into conjunction and that we are, in a manner of speaking, suspended between these two entirely different realms. The triptych "Three Studies for a Crucifixion", 1962, (ill. 7) strikingly depicts this in a clear and unequivocal manner.

In this triptych Bacon's illustrates, as a polarity, the two understandings of space he has so far deployed, for the l. h. panel clearly shows the point-to-periphery understanding of space as the two sides of meat are radiating out from one of the Figures - this is Cartesian space under the influence of gravity – where this Figure has all the solidity we expect of bodies in our everyday space. The r. h. panel, however, shows the opposite - the periphery-to-point understanding of ethereal, levity-orientated space. This is indicated by the 'ring of bones' for all the bones of this ring are interconnected and appear to support the flesh of a Figure that is disgorging itself and dissolving, in a way not dissimilar to "Painting, 1946". These 'rings' that occur in both these works are interpretable as being related to an understanding Bacon had of ethereal space, because the perception of a 'ring' is an important experience of ethereal space. Olive Whicher had such an experience and describes its nature,

" ... In a waking dream, I was once poised, high up above the earth, which was far below me. Vertical, arms by my side and toes pointing earthwards, I was slowly descending. Far away in the blue distance, at shoulder level, there was an 'infinitely' large ring of light, which appeared to belong to me. The horizontal ring of light grew smaller as I descended, coming closer and closer on a level with my shoulders, the nearer I came to the earth below; until, at the moment when it merged into, and closed around my shoulders, my feet touched the earth below.." 12.

Whicher's description of a 'waking dream' must not be confused with ordinary dreaming and has more the nature of 'lucid' dreaming where the individual is fully aware of their circumstances but in a 'higher' state of consciousness. 12. It is also known that Bacon spent much time 'day-dreaming', however it is not proposed to investigate this fact here, rather this will be done at a later stage. It is therefore perfectly possible Bacon had experiences of this kind, especially when we consider how there is a hovering quality to both the r. h. panel of "Three Studies for a Crucifixion", where the 'ring of bones' undulate in an uncharacteristic manner than that of ordinary bones, and to the floating flesh on the circular rail in "Painting, 1946". Whicher's description of her experience is also applicable to "Three Studies for a Crucifixion", if we just look at the bare facts. The r. h. panel shows a figure closely associated with a ring and there is a hovering, floating atmosphere that contrasts with the heaviness of the l. h. panel. Whicher states that when her feet touched the ground she was now totally

back within the Cartesian space of ordinary perception, but until that point she retained a perception of ethereal space, and that the closer she came to the cross-over point of lemniscatory space the closer the 'ring of light' came to her shoulders. When the central panel of "Three Studies for a Crucifixion" is examined there is seen a mixture of extremely distorted figures. This panel is a more graphic rendition of the interaction of forms at the cross-over point of lemniscatory space, where there is a movement from one space to the other that involves an apparently chaotic merging and interaction of forms, than with "Three Studies of Lucien Freud". Through the depiction of a turning inside-out in this panel there is a pictorial description given of the descent from ethereal space to earthly space, or vice-versa the ascent from earthly space to ethereal space and the change of consciousness and perspective that accompanies such an experience. Intellectually this experience of a 'ring' has a formal counterpart in the mathematics of Projective geometry, thus mitigating any purely subjective connotations that a personal experience of it may have. 14.

In looking at "Three Studies for a Crucifixion" it cannot be ignored that this is a crucifixion and the significance of this is not that of a formal religious meaning but rather the theme of *sacrifice*. Although Deleuze does not speak of sacrifice in his commentary on how Bacon handled his subject-matter we appreciate that so as to get away from all the associations, connotations and narrative conventions attached to 'crucifixion' scenes when portrayed realistically Bacon had to completely revise its figurative format. It may be that at a basic level Bacon found that descriptions of the light-filled resurrection body of Christ had a resonance for his own extra-sensory experiences of the human body. Quite apart from the religious significance of the Crucifixion it is astounding to consider that human beings can be so selfless as to sacrifice themselves for others, and such acts do occur, but on other levels sacrifice transpires – it is not an exaggeration to say that without the sacrifices of other beings we would not exist – the earth has as its primary motif acts of sacrifice and love, the significance of which cannot be overrated. In ordinary everyday terms it is clear that without the sacrifices of the plants and animals we would be unable to function – plants allow themselves to walked upon without reacting to this indignity and similarly animals permit themselves to be abused and maltreated by us without rising up against this ignominy.

However Bacon's interest was not to be didactic, morally or otherwise, and so this contrast of two types of space serves to introduce his understanding of how these two types of space function within the constitution of human beings, as creatures who are suspended between levity and gravity. Thus Bacon uses the Figure in the l. h. panel, to the right of the Figure from which the sides of meat radiate, to point to the central panel. This central panel contains, as stated, what can only be described as a garbled Figure, or Figures, lying on a bed, and there is an unmistakable air that an act of reconstitution, or coming-into-being, or dissolution is taking place. The pointing Figure's outstretched arm directly connects the central panel to the r. h. panel, and it is possible to discern fleeting embryonic animal-shapes in both the r. h. panel and the central panel, and so the import of the pointing figure, is amongst other things, that it draws attention to metamorphosis as a salient factor in considerations of how the human being develops. Such metamorphoses of forms are as has already been indicated fundamental to Projective geometry, and in consequence to ethereal spaces. Christ's sacrifice, although it permits us to continue with our existence,

also points to a reconstitution (central panel) at an higher level – that there is a relinquishing of something at a lower level that allows something to come into being at an higher level, and this is aptly described by Lehrs

"Whatever type of metamorphosis is followed by a plant … they all obey the same basic rule, namely, that before proceeding to the next higher stage of the cycle the plant sacrifices something already achieved in the preceding one … he saw the plant develop through Metamorphosis and Heightening towards its consummation. Implicit in the second of these principles, however, there is yet another natural principle for which Goethe did not coin a specific term, although he shows through his utterances that he was well aware of it, and of its universal significance for all life. We propose to call it here the principle of Renunciation." 15.

Therefore in "Three Studies for a Crucifixion" Bacon is perhaps giving expression to his own experience of moving between these two spaces, and how he felt on being 'reborn' ('sucked into') in another place. There is a rhythmic quality to this triptych and this is expressed primarily through the contrast of the corporeal condition of the Figures in the two outer panels (a polarity). The Figure to the left in the l. h. panel appears to be 'sucking' in its flesh as joints of meat thus evoking contraction, whereas in the r. h. panel the figure's flesh is expanding outwards. This rhythmic contrast of expansion and contraction, more appositely described by extensive and intensive, is echoed by the movement of the semi-conscious, somnambulant figures in the l. h. panel that appear to be mechanically participating in an unknowable ritual that has an air of something more ancient than the time of Christ's Crucifixion. It has the feel of harking back to the beginning of time itself and being performed in a manner that is almost automated. This rhythmic quality did not escape the attention of Deleuze who states of Bacon's figuration that

"Everything is divided into diastole and systole. The systole, which contracts the body, goes from the structure to the Figure, while the diastole which dissipates and extends it, goes from the Figure to the structure. But there is already a diastole in the first movement, when the body extends itself in order to better close in on itself: and there is a systole in the second movement, when the body is contracted in order to escape from itself…" 16.

Deleuze perceives the presence of rhythm in Bacon's work as extremely complex and operating on many diverse levels, but it is not necessary to examine them all. Primarily Deleuze delineates a 'passive' and an 'active' rhythm and that these are attenuated by other Figures in the works that act as attendants, as with the two seated Figures in the right-hand panel of "Crucifixion", 1965, (ill. 8). 17. This adds another dimension to these 'crucifixion' scenes by Bacon for the presence of witnesses, or attendants, are an extremely important feature of the events surrounding Christ's death and resurrection.

This rhythmic quality that pervades Bacon's work also relates to the feeling system that mediates between thinking and willing, and is characteristic of everything within our organism that works rhythmically from breathing to pulsations of the blood to cycles of emotions. Ernst Lehrs describes the condition of consciousness of this realm as one that is half-awake, or semi-conscious.18. Given the analysis it is not difficult to see that the figures of the l. h. panel are 'characterised by a degree of consciousness half-way between waking and sleeping'. In "Three Studies for a Crucifixion" Bacon developed the qualities of

extensiveness and intensiveness ('issuing' and 'sucking') through a polarity to show how polarities intensify (or heighten) to a third state or condition that dramatises the theme of renunciation, but this work also shows, as indicated above, that these qualities have to be understood alongside the principle of metamorphosis.

"Modern Geometry provides a way of experiencing space and spatial forms, so that the importance Goethe attaches to *polarity* in nature – light and darkness in the *Theory of Colours*, expansion and contraction in the *Metamorphosis of Plants* – may be approached through the transparency and exactitude of mathematical thought ... the discovery in modern geometry of the Principle of Duality – better expressed as the *Principle of Polarity*-which bears on all ideas concerning space and spatial formations, the relationship of 'Centre and Periphery' can be experienced in quite a different way than before, and the needs of biology are met with an exact, scientific mode of thought." [19].

After this work Bacon went on to produce a number of triptychs in this vein where he explored the ramifications of "Three Studies for a Crucifixion", such as "Crucifixion" where Bacon approached the notion of morality without making any judgements. In this work we are presented with a contrast between the figure in the r. h. panel bearing the Nazi arm-band that is being 'sucked' into itself in an excruciating manner and the figure in the central panel, which, although wounded, is opening itself up to the world in the manner of a supreme sacrifice, or renunciation. This contrast has immense ramifications for an understanding of human morality, but it is the difference in how Christ has been depicted that is immediately important. In the first work there is almost an atmosphere of resurrection, or at least reconstitution, given the embryonic animal shapes that can be perceived, and whilst joyful is the last word I would use to describe the overall impact of this triptych it has a markedly lighter air than the second work. There is the evocation of a devotional tone in the first triptych whilst the tone of the second is one of desolation and loneliness that surely must have been felt by those who witnessed Christ's death. The bandaged legs of this work have a decidedly root-like look to them as if they were the roots of a plant that have been shorn of their tendrils. This is reinforced by the upper part of the body resembling unopened blossoms, as if this is the moment when Christ left his earthly body. A flower uprooted from this world and cast aside in some dingy alleyway. Perhaps, also, this is Adam and Eve besides the Tree of the knowledge of Good and Evil after the Fall. To bring these notions into play when reading images is not as preposterous as it might at first appear for Deleuze notes that there are quite definite sensations of 'falling' in Bacon's images:

"We can see here the importance of the *fall* [*chute*] in Bacon's work. Already in the crucifixions, what interests Bacon is the descent, and the inverted head that reveals the flesh." [20].

So Bacon developed the relatively simple geometric structures of the 1950's that surround his Figures to the complexity and sophistication they display in 1969, as in "Three Studies of Lucien Freud". In the process Bacon deepened his understanding of the forces he perceived as playing a vital role in the coming-into-being of a human being to such an extent that by 1962 with "Three Studies for a Crucifixion" he had made himself conversant with the *modus operandi* of these forces, and this has been demonstrated through the texts referenced.

Once this conclusion is reached it becomes apparent that Bacon's images abound with examples of polarities, intensifications and metamorphoses. Further polarities are to be found in "Three Studies of Lucien Freud" and "Three Portraits: Posthumous Portrait of G. Dyer, Self-Portrait and Portrait of L. Freud" between the non-human geometric structure and Lucien Freud in the former, and between the living and the dead in the latter. Stylistically a metamorphosis is to be observed with the development of the geometrical frames from the 'curtains' of Bacon's earlier period that also served to enclose the Figure, so that the effect of 'invisible' forces upon an individual could be assessed. The centrality of this transformation of the 'curtains', stylistically, is pinpointed by Deleuze:

" ... the large fields of color on which the Figure detaches itself - fields without depth, or with only the kind of *shallow depth* that characterises post-cubism It often seems that the flat fields of color curl around the Figure, together constituting a *shallow depth* The Figure of the screaming Pope is already hidden behind the thick folds (which are almost laths) of a dark, transparent curtain: the top of the body is indistinct, persisting only as if it were a mark on a striped shroud, while the bottom of the body still remains outside the curtain, which is opening out. This produces the effect of a progressive elongation, as if the body were being pulled backwards by its upper half ... At its simplest, the position behind the curtains is combined perfectly with the position on the ring, bar, or parallelepiped, in a Figure that is not only isolated, stuck, but also abandoned, escaping, evanescent, and confused The dark curtain falls, but in doing so it occupies the shallow depth that separates the two planes, the foreground plane of the Figure and the background plane of the field, thereby introducing the harmonious relation between the two...." 21.

The importance of this statement is that Deleuze elucidates yet another polarity between the foreground and the background in Bacon's imagery, and Bacon retains the integrity of his vision by allowing the tubular, geometric structures to retain a 'flatness', as can be seen with the work "Three Studies of Lucien Freud". Bacon instinctively deployed elements formally known through Projective geometry, and he did this not as a self-conscious manufacturing but because to anyone with Bacon's perceptual capacities it is seen that they are inherent to that perception. Furthermore, since the properties of Projective geometry are not static in reality but have a dynamism to them Projective geometry, thereby, produces interpretive explanations for the dynamism of Bacon's Figures, and this will be further explored in later chapters.

The inference taken from the above is that Bacon attempted to find ways of depicting how the human being - the Figure - is situated between the two spaces delineated above, and that this had to done in a manner that was in agreement with that which he perceived. But this was not done as an academic exercise but with a keen eye for exposing factors that compose the emotional substrata of our public lives, together with those forces related to our corporeal genesis. Bacon throughout his life was able to combine a rigorous, scientific approach to his subject-matter – the human being – with a profound empathy for those he studied and painted. Bacon's developed his technique so as to avoid the cliché, to get away from the representational and narrative so as to 're-present' his subject-matter in a fresh light, and this is particularly important when considering a 'crucifixion' scene and the centuries of significance it has accrued—how does one approach such a subject and paint it so that hidden dimensions are revealed that tell something about the way we are now?

Notes.

1. Archimbaud, 1993: 41.

2. Archimbaud, 1993: 15.

3. Dumas, 1995: 62-69.

4. Deleuze, 2004: 46-47.

5. " " " : 54, 111

6. Whicher, 1989: 41.

7. Steiner, 1987: 19

8. Kutzli, 1981: 8.

9. Whicher, 1985: 49.

10. See Ernst Lehrs Book "Man or Matter" for an introduction upon the properties of Levity and arguments for its existence. Pg. 190, then *passim*.

11. Although it will not be explored in this volume Bacon is clearly hinting that Dyer had some sort of continued existence after death. This question will be explored in later volumes.

12. Whicher, 1989. 48.

13. Michael Lipson in his introduction to the series of lectures by Steiner "Sleep and Dreams" gives an account of the role of lucid dreaming and in particular references G. Scott Sparrow's book "Lucid Dreaming: the Dawn of Clear Light".

14. "With practice, though, it is possible to see the common line of the two planes moving all over the fixed plane, reaching the infinite when the parallel situation is reached and flashing in from it one side or another, according to the way the pivoting plane moves. In any direction at any moment, the common line of the two places can disappear from the world of measure, but this does not mean that it then ceases to exist; it is still attainable in thought! Rudolf Steiner uses the word 'Umkreis' for this invisible line, a term George Adams translates as 'the Encircling Round'." Whicher, 1989: 19.

15. Lehrs, 1985: 84-85.

16. Deleuze, 2004: 33.

17. Deleuze: 74-75.

18. "Our observation of the functional systems of the human being would be incomplete without taking into regard a third system, again of a clearly distinct character, which functions as a mediator between the other two. Here all processes are of a strictly rhythmic nature, as is shown by the process of breathing and the pulsation of the blood. This system, too, provides a direct foundation for a certain type of psychological process, namely feeling....As one might expect from its median position, the feeling sphere of the soul is characterised by a degree of consciousness half-way between waking and sleeping." (Lehrs, 1985: 34).

19. Adams and Whicher, 1980: 35-36.

20. Deleuze, 2004: 23.

21. Deleuze, 2004: xi & 29.

22. Deleuze, 2004: xi

23. Deleuze, 2004: xi.

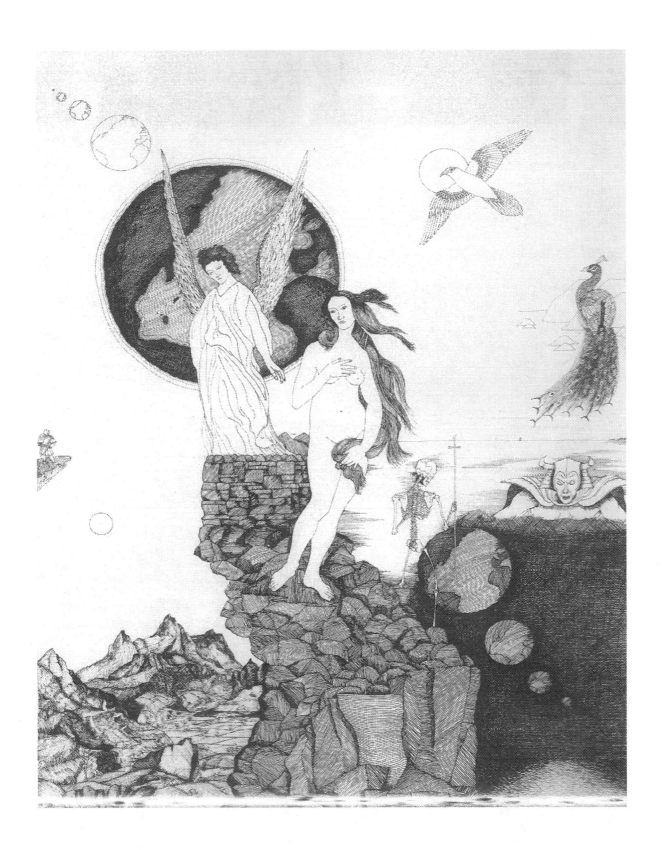

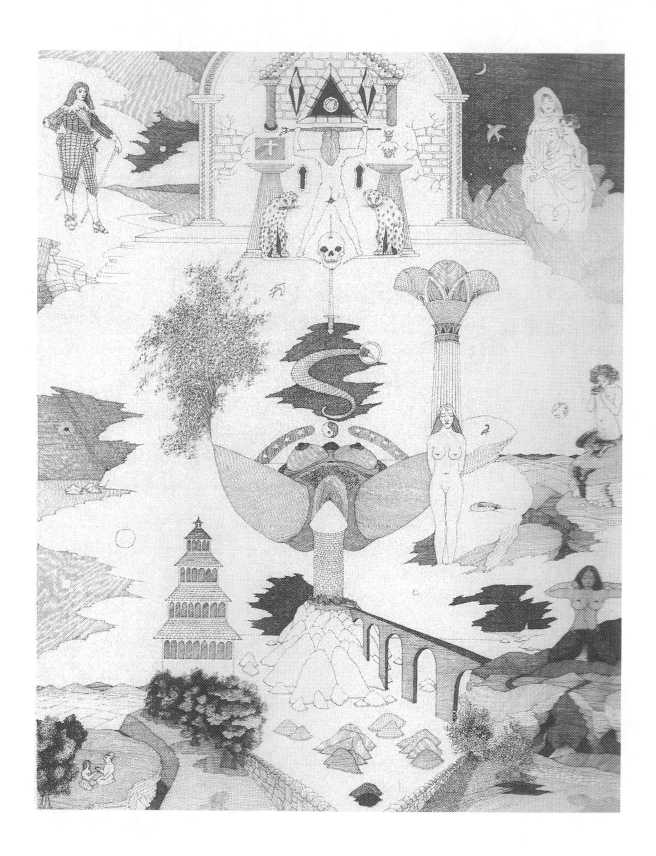

Chapter 3.
Animal Morphology and Elementary forces.

The previous chapter examined Deleuze's and Kurjakovic's comments on Bacon's images primarily from a spatial point of view. The tenets of Projective geometry were found to throw some light on what could be meant by 'impossible simultaneity' and 'a spiritual will'. Through this process, because Projective geometry has been shown to be applicable to the organic world by Adams and Whicher, and that Projective geometry is descriptive of ethereal spaces from which Formative forces issue, it has been possible to initially demonstrate that Bacon, through the analysis of his images, possessed an unconscious, instinctive understanding of how these forces function. This however is only a beginning and before venturing further it is necessary to examine Bacon's paintings of animals. Comments were made above to animals over how they can be perceived as sacrificing themselves so that we may live and how they make visible the invisible by embodying particular sets of drives and instincts. When considering ourselves it is undeniable that we are related to animals through a commonality of instincts and drives. The difference with ourselves from animals is that we are ego-endowed beings whilst they are not, and this makes a fundamental difference between ourselves and animals for an extra factor comprises our make-up that is absent in animals regardless as to the value that is given to the ego. We can also say that as well as being suspended between levity and gravity we are also suspended between an animal and something else, something unknowable, which can only become manifest and known through ourselves.

In addition to the commentary already provided on the significance of Bacon's geometric structures there is also the fact that they could be 'read' as cages. Perhaps meaning that the human being is trapped and ensnared in some way by these structures, (philosophical and religious commentaries on how the human being is confined to, limited by, its corporeality whilst living, in contrast to the freedom experienced in thinking and the Spirit), but this is not the only inference to be taken. Certainly we are constrained to work creatively between the two polarities delineated: levity/ gravity and animals/ something else for this is how things are. If we consider the latter then it is possible that Bacon's use of these cage-like structures indicates a third condition, or polarity, and that is that human beings are

constrained between impulses that have their derivation within the individual, as an animal and personality, and impulses that issue from society at large. This is not say that we have not created social conditions that are inimical to our survival and continue to do so, this is patently the case, and this fact has a direct bearing on Bacon's work if it is viewed under the general term of 'environment'. In this sense the Figures seem to struggle against, or writhe within their environments, in rooms (metaphor for the body) where " ... walls twitch and slide, chairs bend or rear up a little, cloths curl like burning paper". 1. So, initially, it can be theorised that Bacon with his 'animal' paintings wanted to show that the state of society largely relates to our inner nature, specifically with how we have come to terms with our 'animal' nature. Whereby in meeting the instincts and drives that constitute this 'animal' side of our nature we have egotistically contorted and twisted these drives from their original function to our own desires, and that the unnaturalness of this act makes itself manifest as social conditions.

The argument so far has suggested that there is no reason for not assuming that an animal lives in anything other than a seamless connection with its environment where its instincts and drives are unproblematically expressed within its environment. Bacon's handling of this theme, what it means for a human being to have an 'animal-ness' of which it is conscious falls into three distinct categories: animals by themselves in their natural habitat or in cages, (ills. 9 & 10) people with animals, and individuals with heads that have animal characteristics. In works of the first type Bacon is, perhaps, inviting us to consider the effect that the placement of an animal in artificial surroundings has upon that animal's well-being, deprived as it is of the space to act out its normal behaviour patterns. Bacon intensified this polarity by indicating how animals become demented in such environments as zoos, however he did not stop at such an unremarkable conclusion, because in those paintings of animals with people he depicted some where human beings initiate contact with the animals in cages, thereby indicating a kinship between the caged animal and the contestable freedom of the person outside the cage. We can also speculate, by extrapolating from the fact that as these works were produced within the same time-period as the 'Pope' works that Bacon is alluding to the effect that the artificial conditions of modern civilization have upon our instinctual nature. From this the conclusion is drawn that these 'animal' works by Bacon reflect his struggle with such questions as to whether or not we are absolutely founded upon our instincts and drives (Determinism) and whether as a result of being self-conscious we have access to capacities that are capable of mitigating, and transforming, the seemingly inexorable force of instincts and drives.

This point is substantiated by the works produced during this period that have as their subject-matter the satiating, or satisfying, of elemental, instinctive drives - eating and drinking - but the demeanour of these figures is one that suggests that this is done in an 'animal', pejoratively, manner rather than the natural, uncomplicated fashion they are performed in the animal kingdom (ill. 11). If this is so then Bacon indicated that it is the manner by which we deal with our instincts, individually and socially, that is paramount and not merely that we have them. When these works are considered alongside the terrorised 'Pope' it implies that this animal configuration if not exacerbated by the artificiality of civilised living, maintains a precarious existence that is unaffected by skin-deep, civilised customs and behaviour, but which has the propensity to break out in a ferocious and unruly fashion if overly maltreated

or distorted. Consequently it could be said that these works imply that Bacon thought that it is essential that these instinctual and elementary aspects of our psyche be smoothly integrated into our personalities as members of a society. We know that this is not always the case and on this simple level these works examine the contrast between the natural, uncomplicated instincts we posses as an 'animal', and the, sometimes, thoughtless manner by which these instincts are gratified and distorted in artificial environments.

The 'Animal' Within.

Apart from examining how the health of a society is partially determined by the morality of its inhabitants, Bacon extends this concern by considering how artificially constructed social conditions affect the mental health of the individual, through pondering upon the implications for our inner self that the generation of non-natural, synthetic personalities has upon us in order to fit into a wider social agenda. This interpretation is exemplified by the images of 'Businessmen' produced by Bacon, for instance the triptych "Three Studies of the Human Head", 1953, (ill. 12). The figure of a businessman is an archetypal image of conformity and obedience to social norms. This figure represents with its regulation suit and tie the suppression of inner desires, instincts and animal vitality so as to serve the non-human and non-vital, in the form of corporations, or bureaucracies, with all their rules and regulations as to how one has to behave and conduct oneself, and it is not inadmissible to also view the Church, and thus the 'Pope' paintings from this perspective. So in "Three Studies of the Human Head" we witness the degeneration of a smiling, self-satisfied, smug 'businessman' in the l. h. panel, pleased with his situation in life, to that of an agonised and distraught individual in the r. h. panel. Whereby this social veneer is shown to absolutely inadequate in the face of virulent inner forces. Such meditations are fairly run-of-the-mill and widespread in our present time, but they were noteworthy in the 1950's for the pungency of the psychological analysis that these works contained.

"Figure in a Landscape", 1945, (ill. 13) shows an incomplete be-suited figure operating a machine-gun that is indiscriminately firing within a grassy landscape. The landscape has overtones of the controlled and regulated public space of a municipal park, (Russell, 1997: 28), and thus complements the similarly controlled and regulated figure of a businessman or bureaucrat, but the figure is only partial and, therefore, because the machine-gun is firing it is legitimate to state that a brutal and murderous repressed spirit, or temperament, has virtually swept away this figure's flimsy, insubstantial socially contrived surface to reek its vengeance on whatsoever is in its vicinity. This work also evokes a terrible dream where a murderous will has been unleashed for the Figure's head is missing thus evoking the condition of sleep as with "Painting, 1946". Metaphorically a machine-gun represents an unfettered, slaughtering will that has no other aim than to cause death, but it also represents technological innovation. With this image, and other similar ones, Bacon wove into the above themes an extra dimension in that not only is the present mode of technological development inimical to our humanity it is also releasing devastating and ruinous forces previously slumbering in our sub-consciousness. Surely such an image is a wake-up call to be cognisant of the fact that with the technological rush, and dash, into modernity/ post-modernity controlled as it is by corporate lust and greed and an amoral, (professed with pride!!), unethical science, we have sold short essential elements that make up our soul and spiritual constitution, with the result that these elements of our being have become 'rancid' and 'soured' capable only of displaying antipathy to humanity at large.

The third category where Bacon produced images of individuals with animal characteristics represents an intensification of all that he has learnt concerning the accommodation of our 'self' to our 'animal' roots within a dysfunctional social environment. This is brought down-to-earth and given a particularity, as for instance in "Henrietta Moraes", 1966, (ill. 14). In

this work we perceive an integrated and refined fusion of animal and human characteristics. These works occur in a period when Bacon was drastically revising his depiction of the human figure in general – this will be addressed below. The intent here is to depict the manner by which the human being strives to maintain its dignity and composure in-between two opposing equally, compulsive poles, those urges related to our animal instincts in the context of society and those strong desires that relate to our personal tastes, viz. "Man Drinking". With "Portrait of Isabel Rawsthorne Standing in a Street in Soho", 1967, (ill. 15), we can see that her head has a decidedly ape-like appearance with the exaggeration of the lower face and jaw and alongside Isabel Rawsthorne there are odd bull-like shapes in the mirrors. This is an ambiguous image concerning our instinctual desires and their public expression, for we do not know whether or not Rawsthorne is in the act of soliciting – kerb-crawler (technological intrusion into desires) in the background – or just behaving coquettishly. If there is a sexual dimension to this work then it is referring to the self-consciousness that we have of our sexuality, irrespective of whether we are manipulating our sexuality for financial gain or merely displaying it. The odd, bull-like forms of this work relate to other works where a bull is featured as in "Study for Bullfight No. 1", 1967, (ill. 16), which was produced shortly after the above work. The significance of the bull, and this connects with what immediately follows, is the struggle that the human being has in subduing their animal passions, and not specifically to violence. This is an instance where Bacon suppresses the spectacle so as to draw out the inner meaning of the symbol of a Bull, which traditionally is related to the Mithraic mysteries and our coming-to ego-consciousness. Van James in his book "Spirit and Art" makes the following comment " ... the bull forces are also a picture of the instincts and will-power in human nature" 2, and Albert Schutze states that

"When a man comes to the stage of consciously experiencing for the first time his own inner being , he sees that this 'I', or ego, stands against everything that does not belong to it and so [that which does not belong to the 'I'] can therefore be called the 'not-I'. He discovers that the 'not-I' comprises not only of other people, the external world and so on, but also his own bodily make-up, his dispositions, capacities, weaknesses, the whole complex of his desires, inclinations and temperament and temperament. With all this he is certainly connected, but it is not himself. To all of it he can say 'I have it', not 'I am it'. All of this 'not-I' was known to the ancient Mystery-wisdom as 'the Bull' Through his individual activity man must set himself the goal of transmuting in a spiritual sense the 'not-I', the purely natural, in himself. He will then be himself a 'Mithras', who has overcome the bull." 3.

Thus it is that only by overcoming and transforming, our animal instincts and all the passions and desires we associate with our soul life that we find our true humanity, for we can be neither free nor human, only 'Determined', whilst we are under the thrall of them, and Bacon's images referenced so far point to Bacon possessing such an understanding.

Deleuze devoted considerable effort in examining the 'heads' in Bacon's work:

" Bacon is a painter of heads, not faces, and there is a great difference between the two. For the face is a structured, spatial structure that conceals the head, whereas the head is dependant upon the body, even if it is the point of the body, its culmination. It is not that the head lacks spirit, but it is a spirit in bodily forma corporeal and vital breath, an animal

spirit. It is the animal spirit of man: a pig-spirit, a buffalo spirit, a dog spirit, a bat spirit ... the extraordinary agitation of these heads is not derived from a movement that the series would supposedly reconstitute, but rather from the forces of pressure, dilation, contraction, flattening, and elongation that are exerted on the immobile head." 4.

These are profound insights, but for now it is what Deleuze means by stating that 'the face is a structured, spatial structure that conceals the head' that has import. So far it has been suggested that we live within a fragile amalgamation of contrary psychic strands that has the potential for disaster. Thus one aspect of Deleuze's comment, and he also speaks of Bacon's portraits in the same vein, is that this 'face' covering the head relates to that side of our personality formed in response to social and inner demands, whereas the head is a dependency of the body that is derived from our corporeality. The distinction between the two is that our 'face' reflects the influence of invisible forces (emotions, desires, passions etc) upon our physiognomy and is thus something we are intimately tied to, whereas the head is inherited and so to begin with largely outside our making. And so the process of socialization that starts as soon as we become ego-conscious as children marks and forms our immediate appearance, our face. Given Bacon's desire to get away from the representational there would be little point in him producing mimetic portraits in a traditional manner for this fails to capture the key person. It is not that Bacon did not value immediate appearance but he realised that if one creates a portrait in the traditional manner then one has to exert much effort resisting how the sitter wishes to be portrayed. Implying that the essential aspect of a portrait, which is how an artificial 'face' intertwines with a corporeal, 'head' bedrock, would then be compromised by the a reliance upon the ephemeral and contrived alone. There is, therefore, no question of arbitrary or specious distortions to Bacon's portraits or studies of individuals, like Isabel Rawsthorne, and that for Bacon to have created a portrait in any other way would have been for him to produce a 'nothing' that ultimately does violence to the truth of that person's individuality.

From the images so far reviewed it is possible to arrive at a number of conclusions. Firstly there is no hint of a condemnation of our instincts in Bacon's depiction of the animal, rather Bacon focuses upon how we have allowed our instincts to define ourselves through misuse. Secondly although Bacon sees the human being under pressure from particular 'invisible' forces that we cannot immediately cognise, the spaces from which they issue are not approached as a separate order from the space of wide-awake, everyday consciousness, they are depicted as thoroughly interwoven into that space. The impetus of these images is to make us aware that the instincts are inextricably bound up with what it means to be a human being – it is impossible to conceive of human beings without instincts. And for Bacon any consideration of a dualism between the person and there instincts would be an indulgent intellectualism spinning idle fantasises.

A Forgotten Self.

Deleuze comes to the conclusion that the admixture of animal and human characteristics in Bacon's Figures displays a

"...*zone of indiscernability, of* undecidability, between man and animal...". 5.

This is astute for it exactly describes the development of Bacon's animal paintings from their early beginnings to the sophistication of the Isabel Rawsthorne work and the Portraits, and we understand Deleuze's perceptive comment as alluding to how the human being is suspended somewhere between an animal condition and a higher, but as yet undefined state and consequently exists in a sort of no-man's land, i.e. it is undecidable whether we are human or animal. Through depicting the human being in this way Bacon placed a question mark over how we have evolved – do we really evolve from animals or have they devolved from us. Furthermore it could be argued that Deleuze's 'zone of indiscernability' is descriptive of how the 'face' is an amalgamation of a countenance adopted in response to social demands and a countenance determined by our response to our desires and passions, meaning that the response to social demands and the handling of our passions and desires are instrumental components of our *visage*. So if we have a 'face' and personality partially predicated upon passions and desires the implication of the commentary upon the Bull, is not to suppress the animal, which is perfectly natural, but to channel and direct this elemental power into a form (our 'face', character and personality) that produces a 'self' that acknowledges the Other and works to enhance a community spirit that integrates the individual amongst the many. This theme of the Other in Bacon's *oeuvre* will be examined in depth later with a detailed analysis of Bacon's portraits, but for the time being an important point to note is that Deleuze's '*zone of indiscernability*' has a distinct connection to the cross-over point of lemniscatory space, and will be treated in this light henceforth.

Ernst van Alphen in his book "Francis Bacon and the Loss of Self" refers to Deleuze's comments upon Bacon's statements that there are 'levels of sensation', 'orders of sensation', 'domains of sensation' or 'moving sequences' to be discerned within Bacon's Figures. Van Alphen comes to the conclusion that these 'levels of sensation' are not concerned with the arousal of emotions but rather with how we perceive ourselves when sensing, (Alphen, 1992: 30-41). Van Alphen takes this further by saying that Deleuze interprets Bacon's statements to mean that Bacon is attempting, with his Figures, to paint an amalgamation of the senses in that 'he is putting a multisensible figure into the visual range of the eye' (Van Alphen, 1992: 32). The implication of this is that in Bacon's work the Figure becomes one integrated sense-organ, i.e. Bacon is making us aware, in actuality, that there is a unity to our sensing and that all the senses are interconnected. Van Alphen states of Bacon's Figures

"I see in Bacon's tormented figures the neutralization of the differences between the senses in order to emphasize their unity, through the acceptance of their responses, as an uncontrolled force or power in the body." 6.

What did Deleuze himself have to say about these 'orders and levels of sensation'?

"... Bacon constantly says that sensation is what passes from one 'order' to another, from one 'level' to another, from one 'area' to another. This is why sensation is the master of

deformations, the agent of bodily deformations … At first, one might think that each order, level, or area corresponds to a specific sensation: each sensation would be a term in a sequence or series … this true. But it would not be true were there not something else as well … It is each painting, each Figure, that is itself a shifting sequence or series (and not simply a term in a series); it is each sensation that exists at diverse levels, in different orders, or in different domains. This means that there are not sensations of different orders, but different orders of one and the same sensation. It is of the nature of sensation to envelop a constitutive difference of level, a plurality of constituting domains … at a certain level, an organ will be determined depending on the force it encounters; and this organ will change if the force itself changes, or if it moves to another level." 7.

There are complexities with these statements by Deleuze and Van Alphen to be unravelled. Primary to both is this relationship of multiplicity to unity, how something that is in itself unitary can also have a multiplicity at the same time. If the problem is approached from another angle then it is possible to clarify this apparent contradiction. A machine is a whole made up of whatever number of parts that are necessary to make it function, but we never see its governing principle what we see are the physical parts brought together so that it can function as a whole. The idea that co-ordinates these parts so that it can function is invisible, if we do try to think of it we usually start with a particularity, but that is not the founding idea merely a reflection of something already in existence. If we use the machine as a metaphor for the corporeal body and the Astral body, which is an inadequate metaphor but is one explanation as to why the body is theorised as a 'machine', we see that both the corporeal body and the Astral body resolve the paradox of a multiplicity within a unity as does a machine. The corporeal body functions as a unity even though the parts comprising it are of utterly different orders, e.g. the brain and the heart, albeit that they arise from a common ground, and it is able to do this because the substances comprising the heart and the brain are permeated with Formative Forces and Astral forces. Where, again the forces creating the body and ensouling it have a common ground respectively even though the force formations from a particular realm for a specific organ may radically differ from that from whence it came. A machine has none of these hidden realms and the inadequacy of a machine as metaphor for the body is that a machine has no volition outside its user's purposes, this may seem a trite distinction but is of the utmost importance for it is precisely that which makes us human: the ability to have volition in response to emotional states of which we are *self-conscious*. Furthermore machines are based upon the principles of the inorganic world in that the materials it is made up of only function according to the law of cause and effect, they have not moved out of this sphere, and this is obviously not the case with a human being and all that is living. A plant grows and develops, we can see over time one form transforming itself into another form, and it has the capacity to reproduce itself out of its own nature, again something absolutely impossible for a machine, and a plant being able to reproduce itself interacts with its environment and makes adjustments to the size and shape of its organs depending on the conditions in which it grows displaying yet another crucial difference from a machine.

It needs no explanation to say that we are immensely more complex than a machine. A human being does not have an etheric body alone, as with the plant, nor does it just have an etheric body and an astral body alone, as with the animal, but is a creature that has an

etheric body, an astral body and an ego. A plant, an animal, and a human being all live as unity despite the multiplicity of each of the life-forms parts, and the same is true of the supersensible, invisible etheric and astral bodies enfolded into their corporeal bodies. We know that an animal has sensation, and so we realise that without an astral body there is only vegetative existence. At the beginning, in its pristine state, the astral body is a unity that encompasses a multiplicity of possibilities, as is the etheric body. If we take up the idea of a machine again we see, for instance, that thousands of cars leave the factory in the same new state, but these are driven by people and if we followed up the history of each one of them we would find that each of them had deviated from its original state according to how it had been handled by each of its owners, and so from this analogy an insight is gained into how there can be the diversity of human bodies that there is.

The etheric body is a body of Formative Forces that is responsible for the organization of matter into a corporeal body and has created the sense-organs within it so that the astral body is able to establish contact with the outside world, so that from the subsequent 'sensation' the ego can make sense of its experiences as an individual living a corporeal existence. But as we all know our senses do not work uniformly, our sensory organs function with different intensities and levels, smell, taste, touch and so on, even if that which gives us the ability to 'sense' is unified. Together Van Alphen and Deleuze are stressing the importance of the fact that in his Figures Bacon is striving to express the unified nature of our sensing despite the fact that there is a multiplicity of sense-organs that operate through different 'levels', different 'intensities', so that at one moment when we become aware of a rose the sense of sight may be focussed upon its colour, whereas the next moment we may be more aware of its scent, both of which are unified in our consciousness as belonging to a rose by the ego. There are many examples that point to the fact that our senses are unified and inter-related despite their multiplicity, and that we do not function robotically as a 'sensing' machine, where each piece of sensory technology would be separate and discreet. One of these examples are individuals who have sensory experiences where when, let us say, they are listening to music they experience colours, a 'condition' or ability named Synaesthesia and has found expression in German culture with the Gesamtkunstwerk', the total work of art.

From this assessment of our sensory capacities it is possible to propose that there is a sensory unity to our being that underpins normal consciousness of which we have lost sight of, and which is shattered by our acquisition of intellectual powers at the time of learning to speak. As we develop into adulthood and accrue further layers of socialisation we find ourselves further removed from knowledge of this unity. This then would be a hidden primary, foundational sensory and instinctual unity that we have lost sight of, and which only faintly glimmers in our everyday selves having long been fragmented into the piecemeal sensory awareness that characterises our normal adult state of being. Bacon provided clues as to where this sensory unity is located, for there are numerous images painted by Bacon that depict distorted figures lying on beds. The importance of such a scene has already been commented upon above in the triptych 'Three Studies for a Crucifixion', (iii. 7), and how it alludes to a change of consciousness, a sort of 'birth' upon another level of awareness. There are, however, a number of works that Bacon produced in the 1950's that are precursors to the above triptych's central panel, some of which have an explicitly sexual connotation. Two

51

other works that have such scenes are "Triptych (inspired by T.S. Eliot's poem 'Sweeney Agonistes'), 1967,(ill. 17) and "Triptych – Studies from the Human Body", 1970, (ill. 18). In the former work we find that in the two side panels that there are figures depicted as lying on beds, whilst in the latter work we find them in the central panel.

It is not possible to state exactly what they are doing, or even what their precise genders are, but the salient feature is that virtually in all these scenes there is to be found an adult figure that is looking at the figures on the beds. These images have, as stated, overtones of sexual activity and thus direct our attention to the act of procreation, and hence to our origins as physical beings. Bacon confirmed this when he stated in a conversation with the art critic David Sylvester

"...in the orange triptych of 1970 which you said you liked, where the centre panel has two figures on a bed – well, I knew that I wanted to put two figures together on a bed, and I knew that I wanted them in a sense to be either copulating or buggering – whichever way you would like to put it.." [8.]

Bacon was referring in this quotation to "Triptych – Studies from the Human Body", 1970, ill. 18 and light is shed on these scenes, which occur in numerous triptychs, when they are considered alongside Freud's theorizations of a 'primal scene'. David Bakan relates that the activity of 'observing and witnessing' as being central to basic ontological questions:

"We recall in this connection the significance that Sigmund Freud attached to the actual witnessing of the 'primal scene'. We believe that the essential truth of Freud's doctrine witnessing of the 'primal scene'. We believe that the essential truth of Freud's doctrine lies in the fundamental curiosity displayed by children to the genesis of their own being." [9.]

The important point of Freud's postulation is that it theorises that there is a primordial memory of events, sometimes initiated through the witnessing of parents engaged in sexual intercourse, connected to our birth that leads in later years to a questioning of our origins. We cannot know whether or not Bacon had such an experience, despite this these attendants (higher self) that populate his paintings must be bearing witness to something and there inclusion would indicate that this is not something trivial. Regardless as to whether or not our parents are witnessed in sexual congress during childhood the important factor is that of *memory*. The hallucinatory mood of ills.7,17 and 18 signals that these works are concerned with altered states of consciousness in which a 'heightened' memory, or remembrance, plays a vital part. Bacon is drawing our attention to events of our early years with these 'primal scenes' as a time where there is/ was a cohesion to our experiences, which lacked self-consciousness, of the world into which we have been born, and is indicating that he considered it was essential to take account of this stage of our development if we are to understand how we are as adults. Rudolf Steiner states of childhood that

"In the first epoch before the change of teeth, we may describe the child as being wholly 'sense-organ'. You must take this quite literally: wholly sense-organ." [10.]

This categorical statement by Steiner confirms that which was stated above about a primary, sensory unity that only faintly glimmers in the fragmentary, sensory state of adulthood, and so we can say that the intensification, or heightening, to a third state in the 'primal scene'

of the central panel of "Three Studies for a Crucifixion", (ill.7) and other works, refers to the recovery, re-finding, of a consciousness analogous to that we possessed at birth, even if at this stage only through memory.

This line of enquiry becomes credible through the fact that Bacon produced a number of images depicting a man with a child. The two that I will examine are "Man Carrying a Child", 1956, (ill. 19) and "Man and Child", 1963, (ill. 20). The first of these is a remarkable image, for which there are no precedents. It shows a Figure that has an almost priestly presence as it glides across the ground whilst tightly holding a child. This pair is positioned in a geometric structure that instead of being tubular has been transformed into a crystalline structure, and where the man's head has been oddly rendered with a halo-like emanation on its crown. At the present stage of evolution the human being is an amalgamation of physical, etheric and astral bodies where the physical and etheric bodies virtually coincide. However, around the head region the etheric body protrudes to a slight extent. Since it is postulated that these geometric structures are a device Bacon used to represent ethereal space and its cross-over point into earthly space, the conclusion is that Bacon was able to perceive this protrusion of the etheric body. This work stresses how the human being although it evolves into adulthood still maintains an unconscious union with its childhood. If we now examine "Man and Child" we find that the other-worldly atmosphere of "Man Carrying a Child" has disappeared and instead we have a tension between the Figures that indicates strained relations. The Figures have been placed in the recognisable space of a room and are **not** surrounded by the crystalline structure as in "Man Carrying a Child". In this work Bacon paints the normal adult, intellectual state of consciousness that has been divorced from the imaginative faculties and unitary state of childhood, and so these two works examine how our adult sensory awareness arises from an originary, sensory unity of childhood. The impulse to break and transform habitual modes of thought and perception so as to enliven our congress with the world is central to Bacon's *oeuvre*, an intention that made itself plain right at the beginning of his career and continued to underpin his output until his death.

An Essential Bond.

More sense is made of a 'forgotten' self through a closer examination of an animal's existence. L. C. Mees states in his book "Secrets of the Skeleton":

"In the animal there is something that is continually changing its appearance. What is this 'something'? ... Our 'something' works in the inner being of the animal, and when we ask ourselves what that 'something' is, we come to the surprising conclusion that it lets itself be seen in the mature form ... We may describe the animal as the result of an urge working within it which becomes visible in the mature form. How must we comprehend this urge? To do this we have to see the animal in its own environment. Just as the plant lives between heaven and earth, the animal lives between itself and the environment. This animal life can be studied by everyone and can only be spoken of as desire ... The animal is a unity of desire, form and environment." 11.

Environment is not be confused with a particular spot, as a particular spot is capable of supporting a vast number of greatly different environments that contain creatures ranging from worms to elephants. The change that has come about with the human being is that we do not passively respond to, and live within our natural environment, as do the animals. Instead we actively change our environment in manifold ways, and the reason for this is that we have a thinking ego-consciousness and a creative will, and are able from this to make decisions as to what we like and what we think is 'good'. Through this ability civilisations have come into being based upon cities that have evolved into states governed by democracies. All that comprises the natural order and habitat within which the animal dwells the human being has replaced with formations and operations produced by its own thinking activity. One has only to think of the number of radically different environments a city sustains; public, family and work to name a few.

The dialogue has so far argued, through examining Bacon's 'animal' paintings, that artificial and unnatural environments contribute to not only the erasure and debasement of the individual but to the production of agony and mental collapse, and that this is inseparably tied up with how we come to terms with the so-called 'animal' dimension of our being. Since an animal is a unified multi-sensible creature, that is to quote Mees, a unity of desire, form and environment, it can be assumed that we still possess such a dimension to ourselves as animals. An animal does not suffer the disturbance to its sensory awareness that we do due to our intellectual mode of consciousness, where in the attempt to cognise the world and come to knowledge we intellectually extract ourselves from the flow of cosmic creativity, thus creating the illusion that we do not have a 'one-ness' with our environment, thereby precipitating all the *angst* and mental suffering that issues from Dualism and other related discourses. Thus, an implication of a Baconian 'forgotten self' is that only a consciousness that retains the connection we had with nature as children, or as an animal in the positive sense meant here, is capable of rescuing us from an intellectual, rational consciousness that views nature merely as a domain to be ruthlessly exploited for human ends. Bacon's 'forgotten self' urges us to change our thinking so that we are able to re-enter, and live harmoniously with a Nature that created us. 12. Bacon reinforced his analysis of the human condition, and how we can transform ourselves, by implying that we can only progress through a recovery of a 'forgotten' self that has overtones of the bed-rock multi-sensible

unity of animal existence, and so Bacon's crucifixion images created in the 1960's and the animal works of the 1950's are principally, from this perspective, concerned with how we transform our animal origins positively rather than distorting them through our egotistic passions and desires.

Notes.

1. Deleuze, 2004: 59.

2. Van James, 2001. 55.

3. Van James, 2001. 55.

4. Deleuze, 2004: 20 & 58..

5. Deleuze, 2004: 21.

6. Van Alphen, 1992: 41.

7. Deleuze, 2004: 30-31 & 48.

8. Sylvester, 1993: 102.

9. Bakan, 1958: 275-276.

10. Steiner, 1982: 33.

11. Mees, 1984: 7.

12. The bare physical dimension of nature abhors forms and sees to it that they are completely dissolved once the life inhabiting them has departed; nowhere in considering the physical aspect of nature do we find forces capable of producing forms. The only exception is that of crystals and minerals and with crystals we find forms existing in the purely inorganic, physical universe – however it has to be said that the form of a crystal is not derivable from purely physical laws even though physical laws operate within it. With the crystal we have, from a purely external aspect, the striking of a primordial note of life from which the symphony of living beings that inhabit our planet develops. The crystals are the first and most basic action of Formative forces that we are able to perceive in our world, and from this primitive base Formative forces labour to create the diverse living forms that constitute Nature. John Ruskin's phrase 'Always stand by Form against Force' to which he added 'Discern the moulding hand of the potter commanding the clay from the merely beating foot as it turns the wheel', (Ethics of the Dust: lecture X.), succinctly reminds us that in our search for meaning in Nature Form is paramount and not the forces associated with them.

Chapter 4.
Movement Pinned to the Body.

If it is accepted that the principles of Projective geometry shed light upon how Bacon structured his canvasses and triptychs, and that these principles are also descriptive of how the forces of growth unfold, as depicted by Whicher and Adams in their books, then it has to acknowledged that through the language of art Bacon expressed his own discoveries of the critical role these 'invisible' forces of growth and emotions play within the human being. The principles of Projective geometry describe how emotions and growth forces function through polarities, metamorphosis and intensification. By deploying Projective Geometry as an interpretative tool it has been demonstrated that Bacon was aware of the attributes of the space from which formative and emotional forces issue. This discussion will be further validated by aligning mainstream findings with the above postulations, this also has the outcome of providing additional causes for the appearance of Bacon's images.

The Body Schema.

The experiences of amputees has led to postulations that there must exist, somehow, within ourselves a knowledge of the form that the physical body takes, and Elizabeth Grosz considers that 'phantom limbs' are the most convincing evidence for the existence of a 'Body Schema', a sort of plan that maps where everything goes within the body, and furthermore that this is not just related to our external limbs (Grosz, 1994: 70). Grosz states that the connection between the Body Schema and the actual physical body only came to prominence with S. Weir Mitchell, an American Civil war physician, who originally coined the term 'phantom limb'. Following on from Weir Mitchell a number of neurologists became interested in this phenomenon, of whom John Hughlings Jackson and Sir Henry Head are the most prominent. Grosz points out that a conclusion Head came to was that this Body Schema, Postural Body or Postural Scheme in the way it works 'cannot be conscious, but neither is it purely neurological' Grosz, 1994: 65). This is an important point when considering Formative forces, for Grosz goes on to say that Head considered that the Body Schema is three-dimensional and capable of recording and organising information concerning a bodies location in space, that it is extremely plastic and pliable and is able to maintain a record of the last posture or movement undertaken (Grosz, 1994: 66). Whatever else may be said

about the 'Body Schema' or 'Postural Body' (or body of Formative Forces for these are different names for the same thing) it is undeniable, from Grosz's analysis, that it does have a phenomenal existence even if it is not normally perceived. From my perspective the Body Schema or body of Formative Forces contains a plan, or living imagination, that regulates how a particular entity grows into that entity by directing substances to their appropriate place. Goethe's Ur phenomena is a 'living imagination or idea' that he perceived through refining his thinking, feeling and imagination during his empirical studies, and a 'living idea/ imagination' is a projection from the Astral world into the body of Formative Forces so that these forces have a template from which to operate.

Even a cursory and superficial glance of Bacon's *oeuvre* would reveal a wealth of images that contain Figures that are only partially complete, and which, in some cases are attempting to perform actions that are impossible given their physical state. Works of this nature are "Study from the Human Body", 1981, (ill, 21) and "Study for a Human Body (Man Turning on the Light), 1973-74, (ill. 22), but many others exist. All these works depict Figures performing various actions, and as such they are concerned with the deportment and positioning of bodies in space. In some cases there are Figures that are incomplete and in other cases Figures that appear to be emanating from, or disappearing into an unseen space, begging the question as to what part of these Figures' being is co-ordinating the action performed. Nevertheless these incomplete Figures are performing these actions with an aplomb and efficiency that belies their perceived inadequacy. There must be some reason for Bacon constructing Figures in this manner and by suggesting that he was aware that the physical body is co-ordinated by an 'invisible' Body Schema is one such reason. From a different angle Steiner's statements concerning childhood indicate that it is only through a gradual process that the child learns to distinguish its own being from the phenomenal world,

"..does not yet distinguish between the lifeless and the living...considers everything as a unity, and himself as also making up a unity with his surroundings. Not until the age of nine or ten does the child really learn to distinguish himself from his environment." [1]

Childhood is a time of intense activity for Formative forces as the physical body is developed, and the child whilst learning how to manipulate its corporeal body, which is a combination of physical substances organised by Formative Forces under the influence of the 'Body Schema', also has to learn the manner by which this body is distinguished from objects in its surroundings that are lifeless, a process that is never fully completed even into adulthood, one has only have to think of the number of times objects are blamed rather than ourselves when we bump into them. Within the field of Developmental Psychology many studies have been carried out on how young children develop their awareness of space. To quote Andrew Wellburn from his book "Rudolf Steiner's Philosophy",

"It is significant that perspective begins to be understood at around the age of nine ...For, if the ordering of things in perspective were simply a matter of sorting out how to judge elements in our perceptual field, one would actually expect children to master it much earlier. Experiments show that in fact children younger than nine, who do not yet grasp perspective, nonetheless already have very good judgement concerning the apparent sizes of things....Yet perspective is understood only later: so that it clearly does not derive directly from perception – from direct comparison of apparent sizes." [2]

Foremost in this field is Jean Piaget, (1896 –1980) a Swiss psychologist from whom Wellburn quotes the following

"In fact', Piaget writes, 'the concept of projective space...requires a co-ordination of viewpoints and consequently an operational mechanism of transformation much more complex than the perceptions corresponding to each these viewpoints considered in isolation." 3.

Meaning that as we become ego-conscious we have to create a perceptual construct of the world (perspective) that takes account of the ego-consciousness of others. Is there any evidence of this understanding in Bacon's images? Well van Alphen's commentary on Bacon's work also includes a reference to M. H. Abrahms' book "The Mirror and the Lamp: Romantic Theory and the Critical tradition", where Abrahms contests that we can begin to know how our minds function through two metaphors: The Lamp and the Mirror, where the lamp acts as a symbol for ego-consciousness, for how we project out from ourselves when cognising the world whereas the mirror refers to how we reflect the world in ourselves and act as receivers. 4.

There is no question that Bacon knew of either Steiner's or Piaget's ideas – none of the biographies of Bacon, nor his statements, point to him having such interests – yet through the tenacity of his observation, and the rigour of his thinking, he produces the work "Study for a Human Body (Man Turning on the Light)". Given what has been stated of the Body Schema, and how when as children we become ego-consciousness we then develop a perspective vision, then this work indicates that the acquisition of this ability is not merely a concern of the physical body alone, but relates to the development of an organisational sensing ability within the consciousness of the individual. If It was not known otherwise the assumption would be that Bacon was merely illustrating particular theories on human development, for "Study for a Human Body (Man Turning on the Light)" is an image that records the moment of becoming ego-conscious in relation to spatial awareness, and this is made plain through the Figure switching on the light.

Bacon's subversion of classical perspective was not an arbitrary act or whim, but serves the purpose of dismantling our adult perception of the world so as to indicate the consequences of an intellectual cognition of nature; namely how we have become estranged from the world and our environment. By investigating motion in relation to posture Bacon demonstrates that he was conscious that there is an 'invisible' formation underpinning our physical bodies that has a shape analogous to that physical body, a Body Schema or Formative body, and that it is only with time, through learning how to control our physical and Formative bodies, that we realise that we are different to our surroundings as an ego-conscious fact.

Strikingly Bacon's Figure as it developed from 1950 onwards appears to have gained the ability to float, or glide, over the ground – it appears to have an inner buoyancy. Thus those Figures that display these characteristics give the impression that they are being co-ordinated by an unseen order and resemble puppets that are choreographed by an invisible hand. Even the eviscerated flesh and the bones to be seen in his works have a liveliness and animation that is at odds with their lifeless condition. These Figures, therefore, act in a gravity-denying manner whilst giving the appearance of conforming to injunctions that are

hidden from the gravity-influenced space in which they are placed. There are examples that make this clear, in particular, "Portrait of George Dyer Riding a Bicycle", 1966, (ill. 23). In this work we see George Dyer furiously peddling his bicycle and appears to have taken off in the process, and to be free-floating through space. We are given the impression that Dyer is performing such a spectacular stunt that the effort is causing parts of his body to unravel and protrude. From this commentary upon the 'Body Schema' it is clear that we are dealing with a phenomenon that permeates the whole of the body, which even though it is invisible to ordinary perception has so much vitality and life that individuals believe their missing limbs are present. Indeed one is justified because of this to state that it is more primary than the physical body itself, for it continues to function even when its physical counterpart is missing. From this perspective Head's empirical observations highlighted by Grosz come close to a definition of the Body of Formative Forces, or Formative Body. Furthermore when she quotes Head that 'This co-ordination cannot be conscious, but neither is it purely neurological' this also is an apt description of the intermediate position that the body of Formative forces occupies between our physical body and the other higher members of our being, the Astral Body and the Ego.

Deleuze's sustained analysis of Bacon's Figure led him to theorise it within the terms of his own concept of 'the body without organs':

" A wave with a variable amplitude flows through the body without organs: it traces zones levels on this body according to the variations of its amplitude ... An organ will be determined by this encounter, but it is a provisional organ that only endures as long as the passage of the wave and the action of the force, and which will be displaced to be posited elsewhere. 'No organ is constant as regards function and position The entire organism changes colour and consistency in split-second adjustments'. In, fact, the body without organs does not lack organs, it simply lacks the organism, that is, this particular organization of organs. The body without organs is thus defined by *an indeterminate organ*, whereas the organism is defined by determinate organs." 5.

It is true that Bacon did not depict specific organs in any of the Figures he painted, even though as we look at these Figures we suspect that they are somehow present. Thus Deleuze sees in Bacon's Figure an attempt to bring to light forces that underpin these organs of the physical body. The Body Schema as defined above merely registers the lack in some part of the body, however it must have an indeterminacy to it so as to be able to cover the multiplicity of functions and differing constructions of the organs that comprise the corporeal body. To take this thought further Ernst Lehrs states that

"We have seen that the presence of waking-consciousness within the nerve-and-senses system organism rests upon the fact that the connection between the physical body and the etheric body is there the most external of all. But precisely because this is so, the etheric body is dominated very strongly by the *forces* to which the head owes its formation...What can now be added is that, in consequence, the physical brain and the part of the etheric body belonging to it – the etheric brain – assume a function comparable with that of a mirror, the physical organ representing the physical mass and the etheric organ its metallic gloss. When, within the head, the etheric body reflects back the impressions received from the astral body, the I becomes aware of them in the form of mental images." 6.

For the time being the important part of Lehrs' statement is that Formative forces are most external in the head region, and the fact that there is an 'etheric brain' as the counterpart of the physical brain. When thinking of the Formative and Emotional bodies it is perhaps difficult to visualise that these bodies are in constant flux and movement, whilst being capable of creating definitive forms. A flowing river gives an inkling of the Formative Body in that it has different intensities and levels to the flow, (there are flows beneath the surface as well), and that precise forms are created in this flow according to the physical terrain it flows over, which change completely when these circumstances alter.

It is suggested that Deleuze's description of a 'body without organs' comes close to an understanding of how Formative Forces act under the influence and direction of Astral forces. If this accepted then there is a congruence and correspondence between three factors: Bacon's Figure, Deleuze's 'body without organs', and the 'Body schema' all of which I argue bear similarities to what is known of the working together of Formative forces and Astral forces to create the human body. What the 'Body schema' and 'body without organs' lack as models and concepts is that they do not have a *modus operandi*, that is there is no explanation for how the substances of the physical body are moved around so as to create its complex organs, bones, flesh, skin, nerves, and so on. This achieved for Formative Forces through a *living* image of the human body radiating into these forces from the Astral world, and this acts as a template for these Formative forces, so that substances are guided to there correct place in the physical body. This should cause no difficulty for an 'idea' regulates and determines a machine's working, and this 'idea' we never perceive under normal circumstances, but nevertheless carry within our thinking. To start with, either consciously or unconsciously, it is only the inventor, who in a flash of inspiration, sees the founding idea of a machine, which afterwards acts as a template for future models. The most important aspect of a machine is this founding 'idea' and not the physical substance of its later manufacture.

To dramatically characterise this it can be said that all that is living is basically a Formative form/ idea cloaked in physical substances, a combination that would be unaffected by the loss of its physical counterparts, just as the 'idea' of a machine does not cease to function if a part of the machine malfunctions, but where a machine ceases to function if a part is missing. These *living* images that direct the Formative Forces and create the forms of life we see in the physical world are known as Archetypes, or Ur-images, to use a Goethean terminology, and are described by Lehrs in his book "Man and Matter. 7.

A Fundamental characteristic of Formative and Emotional Bodies is that they are bodies of light and this is brought out by Olive Whicher when she relates in her book "Sunspace: Science at the Threshold of Spiritual Understanding" that

"It is not through my physical body that I experience being in reality a body of light. Living in a body of darkness; I experience this with another member of my being, of which I can learn to become aware. It is the ether-body, or body of formative forces, which forms, in its relationship to the nerves-senses, the rhythmic system and the metabolic-limb system, the basis for the soul forces, which are also threefold in nature – thinking, feeling and willing."
9.

In this vein Deleuze indicates just how integral light is to Bacon's Figuration with the following comment,

" ...the maximum unity of light and colour for the maximum division of Figures .. It is light that engenders rhythmic characters ... Everything becomes aerial in these triptychs of light ..." 10.

Body of Light.

Bacon's Figuration is composed of different orders of Figures, and there is an order of Figures that so widely diverges from normal expectations of painted figures as to appear literally fantastic. These Figures lack the density and rigidity of a human being's corporeal constitution instead these Figures are evanescent and translucent in comparison, and with these Figures there is the impression that they have an internal dynamism, as though permeated by a mysterious, inner light that is in constant movement. By comparing "Study for a Pope, VI", 1961, (ill. 24) with "Study of Red Pope", 1962, (ill. 25), it is apparent that the latter has the hallmarks of a traditional representation of the human figure whereas the former lacks the solidity and substance we associate with figuration that attempts only to capture the physicality and heaviness of the human form. The Figure in this work has an evanescence and translucency, as though permeated by an inner light that has given it a plastic, bubbly quality as though its bones have dissolved into light.

It becomes apparent that Bacon in this period was experimenting to find ways of depicting his new understanding of the human being. The evanescent and translucent nature of Bacon's Figuration has to be considered alongside Whicher's comments above that the Formative body is light-filled, luminescent and in constant movement. Bacon's Figures have a high degree of distortion, however, this is only a first impression, for when we examine these Figures we see that, in many cases, this distortion is the merging of two types of metamorphosis, one of which concerns the inner constitution of the body, as with the Figure in the r. h. panel of "Three figures for a Crucifixion", whereas the other is concerned with the surface of the Figure. It sometimes appears that the skin of his Figures has acquired volatility giving it an animated life of its own. This relates to the 'sucking' effect of Formative forces already remarked upon. 11 There is thus a sort of two-way process where Formative forces work in from the periphery, the infinitely distant plane, meet the physical forces and in so doing draw physical substances outward, and this occurs at the cross-over point of Lemniscatory space, thereby giving rise to the rhythmic movements inwards and outwards that are characteristic of any living organism.

Analysis of the composition of Bacon's Figures thus reveals a tendency to get away from viewing the human body strictly in terms of the rigidity that the skeleton produces within the body, for Bacon realised that attempting to cognise the human form purely from the rigidity of the skeleton, the most mechanical and mineral aspect of the body, distorted one's vision as to how the rest of the body functioned.

Metamorphosis: Flesh and Bones.

L. F. C. Mees in his book "Secrets of the Skeleton" presents an exposition that demonstrates how all the bones that comprise the human skeleton are in fact various transformations of each other. Thus in the chapter 'Metamorphosis in the Human Skeleton' Mees illustrates, with the aid of diagrams, how we are able to follow the paths of transformation from one skeleton part to another, for example

"In the first place, we can say that metamorphosed shapes from the axial skeleton can be recognized in the shape of the skull bones. Just as the girdles and the limbs were a metamorphosis of the vertebra-ribs unit...." [12].

Bacon's growing understanding of how the Formative forces function made him realise that it is only through mobility and transformation, the coming-into-being, and not the finished and the rigid, that the human body can be understood, and this realisation led him to depict Figures that were plastic and in states of metamorphosis. The r. h. panel of "Three Studies for a Crucifixion", shows a figure in a state of transformation from the pelvis upwards in a manner similar to Mees' description. The work "Triptych Inspired by the Oresteia of Aeschylus" is a complex work where we have images relating to transformations of the skeleton in the central panel, and to the 'Body schema'/ 'body without organs'/ Formative body in the r. h. panel, with what looks like a monstrosity made up of distorted organs in the l. h. panel. The Figure in the central panel has been ruthlessly dissected to reveal its skeleton and, again, it is seen that the process of transformation is from the pelvic upwards. All the examples of skeletal parts to be seen in the works referenced so far are depicted in a manner that suggests that they are not rigid and lifeless but are animated and able to change. However if the human being is to be considered as an integrated whole in which all is related and capable of transformation and not as a mechanical assemblage of parts, then we have to do just that. Additionally it is not only the skeletal framework that can be viewed as possessing possibilities of metamorphosis, it is also possible to perceive how one organ transforms into another. [13].

Mees in his book presents an exposition of these principles for the general public in simple and easy to understand language, however it has to be acknowledged that Steiner's teaching on this subject penetrated to the deepest level it is possible for us to imagine, and Steiner demonstrates the absolute mutability of human organs from a unitary principle, by showing how all our organs can be understood as transformations of the brain. [14]. This reminds us of Deleuze's 'body without organs', especially as he described it as an infinitely mobile and *indeterminate organ'* that is 'living, and yet nonorganic' (Body schema)(Deleuze, 2004: 47). It is argued, because of the plasticity and mobility of Formative Forces, that this is one reason why we perceive such a bewildering, dynamic interpenetration of flesh and bone in Bacon's work, of which the triptych "Triptych, Inspired by the Oresteia of Aeschylus" is a sophisticated example. Steiner's radical proposition can be familiarised together with the stringency of Bacon's examination of the human being by returning to Bacon's 'animal' paintings.

When referring to the plasticity of Formative Forces Steiner, through a series of blackboard drawings, illustrated how if you removed portions of the human head and distorted others

it was possible to create any animal head imaginable.[15] Through this exercise Steiner indicated that from a particular perspective the human being bears, potentially, the whole of the animal kingdom within it. Steiner thus gives precise descriptions of the extreme mobility and malleability of Formative Forces but more importantly demonstrates how this is approachable from a purely external, physical perspective. This again recalls Deleuze's definition of the 'body without organs', particularly when speaking of the 'head' as the culmination of the body: 'a pig-spirit, a buffalo-spirit, a dog-spirit, a bat- spirit'. (Deleuze, 2004: 20). In previous sections it has been shown how at the beginning of the 1960's Bacon struggled to create Figures that were more plastic and mobile, so as to record his growing awareness of the absolute plasticity of the human form that is always in states of transformation. It has also been seen how in the 1950's Bacon examined a process of mutability between human and animal heads. Although we cannot go so far as Steiner and say that Bacon shows how 'man bears the whole animal kingdom within him' we can say that he was very close to this understanding for the animal forms that we find in various works, such as "Henrietta Moraes", 1966, relate to no *specific* animal. The impression given is that Bacon is implying not that the human being attempts to eradicate the animal, but that the human being works in such a way as to suppress, or rather transform, any particular animal specificity in its form.

Study of Bacon's translucent, mobile Figures reveals another striking quality and that is that they have no end-point to their process of change, they have an implicit reversibility where there is the feel of a movement from one state to another and back. The oscillatory condition of these Figures illustrates from one angle the confluence of Formatives Forces and mechanical forces when they meet at the cross-over point of lemniscatory space, and also relates to the statements on the reversibility of the Gestalt figures in respect of Bacon's geometrical frames. But we cannot definitively say with these Figures that there is, in the case of the animal works, a development from animal to human, or that the human being is in the process of regressing to a state of bestiality, we can only say with these works that there is a state of flux between the two; Deleuze's 'zone of indiscernability'. Additionally everything seems to be taking place at the same moment in a way that recalls Kurjakovic's 'impossible simultaneity'. The overall impression is that if it cannot be said that time has stood still, it can be said that with these Figures time is behaving in a highly unusual manner. That time is somehow moving in and out of itself as if, to use Deleuze's phrase, there is a 'vibratory, rhythmic transformation'.

Notes.

1. Steiner, 1982: 48.

2. Wellburn, 2004: 110.

3. Wellburn, 2004: 111.

4. Van Alphen, 1992: 60.

5. Deleuze, 2004: 47.

6. Lehrs, 1985: 453.

7. Lehrs, 1985: 390. Goethe is the first individual of the modern era who through a co-ordinated use of his powers of reason and imagination developed the capacity to perceive the invisible realms referred to here.

8. Steiner, 1982: 34.

9. Whicher, 1989: 50.

10. Deleuze, 2004: 84.

11. "Leichte works *centrifugally*, drawing or sucking living substance upward and away from the all-relating point or relative centre of the living process, towards the Leichte-plane...... *The peripheral, Etheric forces work inward and unite with the physical, but in doing so, the levitational force draws or sucks the physical outward.*" Adams and Whicher, 1980: 105.

"In one lecture, he even used the words 'surface-like' and 'planar' to describe the forces working inward from the universe, and he described the 'Gegenraum' as a 'plastically formed space'. 'It is only possible to study it, if we think of it as being formed from out of the whole cosmos; if we can understand that these *planes of forces*, approaching the earth from all sides, come towards man and plastically mould his formative-forces body from outside." Adams and Whicher, 1980: 89.

12. Mees, 1984: 61.

13. "...one can imagine the metamorphosis of the limbs into the muscles of the face Is it not possible to think of the heart- as an organ between the arms and legs- continuing to live as a metamorphosis in the tongue between the jaws." Mees, 1984: 69.

14. "Now see what we've done: we have made an eye out of the brain! What actually is the eye? It is a small brain, so fashioned by our human spirit that the actual nerve apparatus is pushed back to the rear wall, where it becomes the eye's retina. This is the way in which nature's architects, the modellers of form, work; this is the way they shape. There is basically only one blueprint for all the organs; it is modified only in the particular, as needed. If I could speak for weeks, I would show you how every organ is nothing other than a modified little brain and how the brain itself is also a sense organ on a higher level. The whole human organism is built out of the spirit." Steiner, 1999: 48.

Conclusion.

Imagination made them, and she is a better artist than imitation; for where the one carves only what she has seen, the other carves what she has not seen.—Philocrates.

Whether or not it is possible for any human being to be able to perceive the 'invisible' realms outlined above is, in one sense, besides the point. In fact some readers may have already understood what I believe to be the most important part of my *critique* of Bacon's *oeuvre*, however, since I am confident that Bacon had, by birth, perceptual capacities able to do so I would not have felt comfortable omitting this component of his consciousness from my analysis. So let us assume that I had omitted this aspect in my interpretation.

This still does not mean that the Formative Forces, Astral Body, Thinking and the Ego do not exist it is quite clear that they do, and it is equally clear that in their essence they are quite separate realms, even if emotions are intermingled willy-nilly with thinking in everyday life. Even a cursory examination of emotions reveals that they constitute our ability to **Feel** and that the emotions related to feeling are able to change into each other. Further examination reveals that emotions do in fact have intensities and polarities alongside their metamorphic properties and that Projective Geometry is an excellent means by which to qualitatively cognise them, to start with, in their most basic manifestation. Admittedly this is difficult to do if one has not first familiarised oneself with how Projective Geometry is applicable to the coming-into-being of a plant. Thus if the human being is itself considered as being comprised of three parts: Thinking, Feeling and Willing, related to the brain, nervous system and digestion (metabolic system), respectively, so as to form a whole, then it is clear that the main focus of the above examination of Bacon's work has been our ability to **THINK in CONCEPTS and IMAGES**.

Thinking can only arrive at solutions that are apposite when it has the appropriate concepts from which to act, and these can only be obtained through an empiricism that 'opens its eyes' to the world. Rather than prejudging what is seen by excluding certain phenomena and valorising that which is perceived by creating hierarchies of value according to various preconceptions with regard to the nature of the Universe. And then only when fructified through our Imaginative powers, as with Goethe (Exact Sensorial Fantasy), so that the Intellectual and the Imaginative are equal partners in the human quest for knowledge. In

effect this means the harmonious marriage of Art and Science, a necessity that has been long advocated by many writers and thinkers, principal amongst these being C. S. Lewis.

If it is accepted that Bacon had embryonic and undeveloped clairvoyant powers then this has further implications. When discussing the evolution of humanity in general terms Rudolf Steiner stated that it was now the case that humanity was in the process of 'crossing the threshold', which means that greater and greater numbers of people are being born who have incipient clairvoyant abilities. I will not discuss his further statements but if this is true then there is no reason that Bacon should not have been amongst that number, for it is nothing special. I will not here even offer evidence that supports Steiner's contention as there are plenty of sources for any interested reader to consult – Colin Wilson's wide variety of books concerning the Occult for instance. What is extraordinary with Bacon, unlike the majority with similar gifts, is that he accepted his abilities as an empirical fact *and then proceeded to focus this ability and create an artistic language suitable for recording his perceptions*. In the above I have given reasons for the appearance of Bacon's images but not specifically for the 'affect', which is the strong emotional impact simply viewing his work has irrespective of nationality, race, creed etc. Partly this is due to his subject-matter but is largely due to another reason. The human being is from one angle an amalgamation of a 'higher' self and a 'lower' self, where the 'lower' self consists of all the baser passions and desires which can become unbridled if the 'higher' self is not sufficiently strong to control the 'lower'. But Bacon was fascinated by this 'lower' self and the struggle of the 'higher' self to gain ascendancy and strove on every level to make this a palpable component of his work (unlock the 'valves of sensation'), so that the viewer has an unconscious intimation that their viewing is in no way disinterested but that they are viewing their own soul processes displayed before them. Be that as it may for there is yet another dimension to this dialogue and that is this, through our lower passions and desires we change the substance of the astral world into deformed and malignant caricatures (such as the Furies) of our 'higher' self that are persistent and difficult to dissolve. These surround a person with such passions and desires and are perceptible to clairvoyant vision, in fact it is stated that beings of this order are invariably the first things to be seen once clairvoyant perception is developed. Since Bacon was born with these faculties and as far as the conventional biographies are concerned received no advice upon these matters he would have had to learn how to focus and harness his abilities, similarly to Goethe, by himself.

However the conventional approach 'glosses over' the fact that very little is known of Bacon's life before the age of 35 when he exhibited "Three Studies for Figures at the Base of a Crucifixion" at the Lefevre Gallery in 1945. Very little is known of his relationship with the enigmatic painter Roy De Maistre. But what is crucial here is that Bacon was wise enough to realise that any talk or discussion of extra-sensory perception, and the like, was absolutely forbidden if he wished to be taken seriously and develop a career in the art world, a situation not very different 65 yrs. later. Bacon was a gifted painter with remarkable abilities, but it is evident that he was unable to distinguish between his 'higher' self and 'lower' self and viewed the world through the auspices of this state. However, what distinguishes Bacon is the fact that he investigated what he perceived without prejudgment and was, as such, a true scientist. Did Bacon perceive these 'living imaginations/ ideas'? I believe it is entirely possible that he did and the rest of my research into Bacon's paintings, of which the above is a part, further substantiates this claim.

Further Thoughts.

It may appear that this text contradicts itself in that it both validates and repudiates the effectiveness of 'social conditions' as an interpretive tool. Apart from the fact that contradictions sharpen thinking and when resolved open upon vistas of knowledge previously hidden, 'social conditions' have not been broached in the above because the focus is different here. There can be no doubt that every individual is born into a particular nexus of 'social conditions' that is an interpenetration of unique and generalised factors. For instance there is an individual uniqueness to a particular child's relationship to its parents, and this is true regardless of how many children are present in the family, whereas the country of residence will be a factor of influence that is applicable to each member of the family. Even though this is the case this does not preclude an individual from having a consciousness of 'world conditions' that facilitates an awareness of factors that are universal in that they are of relevance to a human being irrespective of race, colour or creed. It is not claimed that the above presentation is the absolute truth, that cannot be the case, but neither is it unsubstantiated speculation. Through deploying the propositions of Projective geometry interpretatively a standard is created by which to judge any postulations or hypotheses. Furthermore when there is a consonance between two distinct modes of cognition, in this case between Bacon's utilization of the Language of Art and Steiner's Philosophical discourse greater credence is endowed upon any claims.

Two recent publications "The Violence of the Real", a collection of essays, and "Francis Bacon" by Wieland Schmied provide examples of how thinking reaches a certain point but then is unable to progress further. Schmied's extensive examination of the spatial construction of Bacon's images reveals that, similarly to van Alphen, it is the lack of appropriate conceptual structures that prevents further progress in his thinking. Schmied in his commentary emphasises points that from this perspective are very significant;

"Step by step, he replaced these traditional ideas with a completely new model of pictorial space, conceived as a nexus of interlocking systems that are in continual conflict but also have a mutually reinforcing effect." [1.]

The traditional ideas are those related to Classical Perspective and Schmied views Bacon as subverting these in his pictures, however, as pointed out, Classical Perspective describes how we relate to each other as ego-endowed empirical objects purely from the material and mechanical dimension of our being. The space of the *inorganic* is thus described by the classical paradigm and if this was all there was to a human being then it would be sufficient. The organic world, and consequently the 'spiritual' dimensions of a human being require a different paradigm and this has been described above. It has also been pointed out that anything living is the inter-weaving of these exclusive space systems and Schmied's quote above instinctively encapsulates the reality of how these separate systems meet at the cross-over point of lemniscatory space. Schmied makes many pertinent comments, especially relating to how individuals create space that is emotionally charged, even if he sometimes speaks of space, in the abstract, as possessing volition, which naturally is impossible unless it is believed that there are spaces composed of entities that possess volition!

"Space creates individuality, and vice-versa: every manifestation of the individual carves out

its own space…The relationship between space and individuality has many ramifications. Bacon even pursued the theme beyond the human figure, posing the question as to whether the creation of individuality through space was limited to the realm of the human. Perhaps it could also be found in nature: for example in landscape. Could a natural object or a piece of scenery acquire individuality through space " [2].

Armin Zweite, a contributor to "The Violence of the Real", makes the comment:

"Indeed, we can conceive, of Bacon's works as a 'drama of nothing' in that nothing opens up behind his images, and their sense is exhausted in what is embodied in paint on the canvas. At the same time, the pictures are also a 'drama of something', because things are shown exploded deformed fragmented liquefied or dematerialised, as if in the process of emergence and disintegration." [3].

Sweite makes the above comment within the context of Merleau-Ponty's essay "Eye and Mind", which analyses the act of painting from a Phenomenological perspective, where Merleau-Ponty states concerning our relationship with the World and the ability to sense that "the body's seeing must in some way take place within them, and their manifest appearance must connect with some hidden visibility within the body", [4], where them refers to the perceptible sense organs of the human body. It is perhaps not apparent to everyone but eyes, ears, noses and nerves do not of themselves sense anything but merely transmit and that, as Merleau-Ponty correctly points out, this has a relationship to a 'hidden visibility' within the body. These tautologies, or oxymorons, by Sweite and Merleau-Pony indicate that with their intense examinations the capacity for language to encompass meaning is strained to the limit. A logical, evidential description has been presented as to what a 'hidden visibility' could refer to, but what is Sweite referring to? One answer is that Bacon within his imagery completely dismantled the codes for mimetic representation thereby refusing to be seduced into the belief, because of the evidence of his own perceptual capacities, that the human body could be understood by merely intellectualising, in an abstract manner, upon its surface appearance, and that to understand the human being one had to penetrate that appearance so as to cognise the inter-relationship of the soul (emotional aspect) and spirit (capacity to think) with how the physical body is created: a 'drama of nothing', so to speak. Whereas a 'drama of something' would in that case refer to Bacon's attempts to depict and represent the make-up of the human being as he perceived it as the conjunction of the two types of space, one related to levity and one related to gravity, and their respective forces.

Neither of the above authors possesses the conceptual framework to make this apparent, and, indeed, further examination of Scheid's comments makes this clear. In his analysis of "Three Studies from the Human Body", 1967, Schmied states

"The three figure studies of 1967 are set in, or cast down into, a continuum of un relieved blackness……assumes that all three figures are located in the same space, which is clearly not the case. The free-floating figure on the left seems to have escaped the constraints of gravity, yet the figure in the centre, hanging from an horizontal bar, is pulled towards the ground by its own weight. Meanwhile, the figure on the right of the picture appears to be resting in the nocturnal void as if it were resting upon the ground. Each figure has its own private space, which it refuses to share with its fellows." [4].

Schmied thus describes a Baconian space that in one sense is 'no space and yet all space' that is capable of expressing both the effects of gravity and non-gravity (levity), to which the Figure, or Figures, are subjected. Schmied implies that in fact two, possibly more types, of space are depicted by Bacon as being pertinent to the human being. Scientifically it is abstractly postulated, mathematically, that the world we inhabit has interwoven within it numerous types of space, or dimensions, and from the quotation above Schmied believes that Bacon was cognisant of this fact as a palpable reality. This observation by Schmied impinges upon the sub-text that artistic cognition has a 'knowledge value' equal to that of the scientist, if not more so, because the artist takes account of the qualitative as well as the quantitative attributes of phenomena.

We Must Become as Little Children again and the 'Forgotten' Self.

"I think the analytical side of my brain did not develop till comparatively late – till I was twenty-seven or twenty-eight." 5

If we take this statement by Bacon at face-value then Bacon is telling us that he did not begin to think in a rational, intellectual way until he was twenty-seven or twenty-eight years old. Naturally this is not literally true, the analytical mode had to be present or he would not have developed into an adult capable of negotiating his way through life. To understand Bacon's unusual development it is necessary to further investigate what is known of the state of infancy. Henri Bortoft in his book "The Wholeness of Nature" draws attention to discoveries made in Developmental Psychology concerning how there are changes in modes of consciousness as we grow out of infancy into adulthood;

"Psychologists have discovered that there are two modes of organization for a human being: the action mode and the receptive mode. In the early infant state, we are in a receptive mode, but this is gradually dominated by the development of the action mode of organization that is formed in us by our interaction with the physical environment...The result is an analytical mode of consciousness attuned to our experience with physical bodies. This kind of consciousness is institutionalised by the structure of our language, which favours the active mode of organization. " 6.

It is however a fact that Bacon received very little formal training or schooling, and so his analytical and intellectual powers associated with the 'action' mode of consciousness remained relatively undeveloped, meaning that the imaginative, 'receptive' mode of infancy did not fade into the background, as is the case for the majority of adults. Instead it retained its potency giving him an extremely mobile, imaginative consciousness until a balance occurred in his late twenties. "Figure Writing Reflected in a Mirror", 1976, (ill. 26) is an intriguing work for it shows a Figure immersed in a flow of thoughts that it struggles to control and set down as the written word, this is indicated by the rejected garbled writing/ newsprint lying on the floor. It is as though the Figure is attempting to make use of a medium of which it is only partially conscious and has difficulty in comprehending and manipulating successfully. This painting was produced by Bacon when he was 67, so is this an image of the struggles he had when he was younger in coming-to-terms with his intellectual, analytical abilities? This argument can be expanded by examining the manner by which intellectual language is enfolded into our perspective vision of the world. Before we acquire the ability to speak, we are in a state of non-differentiated communion with the cosmos. This state of bliss is shattered with the acquisition of language, for the language we speak and use to build our concepts is one that is ideally suited to our analytical and intellectual investigation of the inorganic, life-less realm of Nature because our primary life concern is to stay alive within this realm. Our language as such only produces abstractions that merely point to the phenomena conceptually referred to, and this is especially true of phenomena of the organic realm. If I merely say the word, plant, I receive nothing it is only when I produce imaginative representations of a plant and rekindle memories of plants along with my own sensory examination of the plant kingdom that this concept comes to have some life.

Although we particularise and stultify the living flow of the cosmos through abstract concepts

it is not that we are irrevocably divorced from the world, or ourselves, it is that the allure of the intellectual has occluded the primordial essence within our ordinary perception of the world and this essence has to be regained – that is the thrust of the 'forgotten' self to be found in Bacon's images. By alluding to the spoken word through puddles of newsprint Bacon presented us with a meditation upon the problematic nature of thinking, especially when thoughts are presented in the 'dead' medium of the written word. This is clearly indicated by the work "Figure Writing Reflected in a Mirror", where the fact that the Figure is reflected in a mirror emphasises the 'reflection' of thought itself in writing and the act of individual reflection. In this work Bacon underlined the past nature of all conscious thinking by contrasting the 'writing figure' with a lump of garbled newsprint on the floor, pointing to the fact that as soon as we begin to write thought has already happened and evaporated. These puddles of newsprint that occur in numerous works have the appearance of a waste-product that the human being has shed – the burnt-out ash from thought processes that were once living and alive. In our normal consciousness when we think and act we do not realise that the thinking we are consciousness of is not the original act of thinking, meaning that we exist in a state of displacement from that original act. It is as though our normal consciousness is an echo, or an after-image, from the original act of thinking.

Further evidence that Bacon was aware of this disjunction between consciousness and thinking that causes our displacement from the 'now' is to be found in "Triptych-Studies from the Human Body" where we observe that the central panel, seen as representing a 'primal scene', has no newsprint whereas the other two panels do, and so we conclude that this triptych implies that with the onset of adulthood we become severely dislocated from our essential being by expressing ourselves through an intellectualised language and writing. By looking at the inter-relationship between thinking and writing more dimensions are added to the dialogue concerning a 'forgotten' self to be discerned as underlying Bacon's Figuration, for now the appearance of his Figures can be partly attributed to the fact that there is an unconscious struggle within ourselves to make conscious the wholeness of the early years of infancy. Therefore in the light of all that has been stated previously of how Bacon attempted to express how he perceived himself and other human beings, we arrive at the supposition that Bacon considered it absolutely vital that our 'forgotten' self is rehabilitated into our consciousness as a failure to do so greatly impedes our desire to understand why we are the way that we are.

Consciousness: Hand and Eye.

Frank Wilson in his book "The Hand" makes conclusions concerning how the hand when engaged in skilful activity causes neurological development, which in turn creates the opportunity for further creative thinking and language capacities

"We are left with a rather startling but inescapable conclusion: it was the biomechanics of the modern hand that set the stage for the creation of neurological machinery needed to support a host of behaviours centred on skilled use of the hand. If the hand did not quite literally build the brain, it almost certainly provided the structural template around which an ancient brain built both a new system for hand control and a new bodily domain of experience, cognition and imaginative life ... If the hand and brain learn to speak to each other intimately and harmoniously, something that humans seem to prize greatly which we call autonomy, begins to take shape." 7.

Wilson's statement makes it clear that our evolution from so-called primitive states, both corporeally and mentally, to a modern condition is not something that happened through pure chance, but is a development that has been brought about through our willed activity.

The link between our creative actions and our neurological development is not one that we have any consciousness of but nevertheless is taking place through every creative act we perform. This process, however, is not linear and finished, for as we create we are then able to contemplate our production, and through this contemplation initiate further creativity that eventually effects more changes in our neurological state, and so is a process that is 'correlative' and lemniscatory in nature. The human being is not a finished product and the difference now, in contrast to the past, is that we are gradually becoming conscious of the absolute interrelatedness of body, soul and spirit; that thinking effects bodily change through our creative use of the body and that in turn affects how we think through neurological development. In becoming ego-conscious beings we are all heirs to that which was achieved in the past, and it makes a great deal of difference how we think and create with respect to our future development, in effect, henceforth, we have to take responsibility in full consciousness for how we evolve, no matter how tempting it is to dreamily blunder forward influenced by unbridled passions and dead thinking in the same old ways - a new vision is needed.

Light is cast upon the interrelationship between hand and eye by our knowledge of the respective functions of the right and left hand hemispheres of the brain, and Betty Edwards in her book "Drawing on the Right Side of the Brain" explores this interrelationship by pointing to the crossover connections of the left-hand to the right hemisphere and the right-hand to the left hemisphere. The cross-over point for the function of these hemispheres is our consciousness, and the information supplied by either of them is either consciously or unconsciously digested. Edwards goes on to explain that the left hemisphere functions rationally and logically in distinction to the right hemisphere that functions holistically and imaginatively (Edwards, 1979: 40). One of Edwards arguments is that in educating children our culture overemphasises left hemisphere activity and that as a result of this the right hemisphere is underdeveloped;

"But the emphasis of our culture is so strongly slanted toward rewarding left-brain skills that we are surely losing a very large proportion of the potential ability of the other halves of our children's brains. Scientist Jerre Levy has said That American scientific training through graduate school may entirely *destroy* the right hemisphere. We certainly are aware of the effects of inadequate training in verbal, computational skills. The verbal left hemisphere never seems to recover fully, and the effects may handicap students for life. What happens, then, to the right hemisphere which is hardly trained at all?" [8.]

A good question, which this text addresses, but the validity of Edwards analysis becomes more apparent if we continue with Bortoft's analysis of discoveries in the field of child development. Bortoft's commentary revealed that the receptive mode specifically relates to the approximately first three years of life before we acquire the ability to speak, a period when we do not cognise the world through the auspices of our *brains*. The conclusion is drawn, following Edwards' statements, that the action mode relates to the left hemisphere, whereas the receptive mode relates to the right hemisphere, and that the right hemisphere is developed through play and exploration of the world up until the time of learning to speak when the action mode gradually begins to emerge and take over. The action mode becomes dominant with ego-consciousness, after which time as we know, the focus is exclusively, and this has become more so in the last few years, upon the left hemisphere skills and not right hemisphere skills. Perhaps this imbalance goes some way to explain the 'out of phase' character of our consciousness referred to earlier and the experiments of Benjamin Libet that investigate the gap between comprehension and action. [9.]

Despite the gloomy prognosis of Edwards' commentary her main argument is how the right hemisphere can be stimulated, through drawing exercises, during adult life notwithstanding shortcomings in earlier education. The results of Edwards approach concern only rudimentary artistic activity, but at a basic level they confirm Frank Wilson's earlier postulations concerning the relationship between hand and eye. However we can also look at this relationship of hand and eye from the other side, and enquire into the possibility that imaginative exercises can also lead to changes in cognitive abilities and our subsequent creativity. Bacon, similarly to any other artist, strove to find the most striking and original manner of expression, as is shown by his stylistic development from the early 1940's through the 1950's until the mature phase after 1960. The examination of Bacon's stylistic development illustrates how effecting changes in the co-ordination between the hand and eye opens up new cognitive abilities.

What is the Point of Infinity – A Question of Balance?

As referred to it is an absolute need for our cognitive faculties to be thoroughly imbued with a strengthening and disciplining of unfettered imaginative capacities. This is something that cannot be stressed enough. Thus it is possible to find developmental imaginative exercises relating to colour, plant growth and so on, however the concern at present is with geometrical imaginative exercises that enable one to become familiar with Projective Geometry. In particular it is the exercise where one imagines what it would be like to travel to the point-at-infinity.

To do so appears at first meeting to be, literally, a 'pointless' exercise, for where is infinity and where could such a point be located? One way to initially come to terms with this exercise is through Classical perspective, which is an abstract, but precise, representational system expressive of the fact that we ordinarily perceive the world in a particular manner. One of the fundamental achievements of this system is that it enfolds infinity within it as something cognisable by having the 'vanishing' point as the terminus for the spatial disposition of phenomena. That is through the 'vanishing' point a realistic representation is possible for the inter-relationship of phenomena in space with respect to size and distance. So as we view a perspective drawing we see objects getting smaller and smaller the further into the distance and nearer to the 'vanishing' point they are, and these 'vanishing' points, for there can be any number of them, lie upon an horizon the importance of which will become apparent later. Thus this abstract representation is analogous to our own experiences of, let us say, an avenue of trees receding into the distance. In this system 'vanishing' points act as masters that regulate and order the representation of the object-filled world of our wide-awake consciousness. How different this space was represented by artists prior to the creation of perspective drawing; people, buildings, and sundry other phenomena are haphazardly depicted regardless of their size with regard to their relative distances from each other.

Therefore, if we imagine ourselves to be travelling towards a 'vanishing' point, and remain within its strictures, we witness an ever-diminishing world until we reach the 'vanishing' point, or the point-at-infinity. If we then imagine we pass through this point, and still remain within its strictures, what do we now see? If we stay true to the exercise we can only say that we perceive the smallest closer to us with the largest further away as our visual cone expands to, shall we say, the 'plane-at-infinity', we have thus reversed our conditions at the start of this exercise. This gives one a first-hand experience of the cross-over point of lemniscatory space, and its repetition brings about a mobility of thinking and seeing that felicitates an enhanced awareness of the transformation of forms in the living world. It is also equally possible, so as to develop this experience, to imagine that one is on a plane that is moving towards 'the plane-at-infinity' and that the closer this plane we are on comes to the 'plane at infinity' so it expands until it becomes infinitely large when it reaches the 'plane at infinity'. By doing this exercise one's consciousness has encountered an absolute focus and an absolute expansion - a systole and a diastole - and realised their inter-relatedness whereby one is the other perceived from either position. Given that the plane-at-infinity is infinitely large it includes all possible planes that one could have started from, and all that could have been inscribed on any particular original starting plane is simultaneously

connected with all that which is inscribed on any other plane that one could have chosen to start with.

It is argued that in his triptychs Bacon, through a denial of narration, produced a simultaneity that presents us with a 'being-ness': 'the force of eternal time, the eternity of time, through the uniting-separating that reigns in the triptychs...' (Deleuze, 2004: 63-64). The above imaginations thus not only develop our cognition but they also provide a way of entering into Bacon's triptychs. If we now imagine ourselves as Francis Bacon stood in front of one of his blank canvasses, we know that he spent considerable lengths of time imaginatively contemplating his subject-matter, but this was not done so as to come up with a ready-made image which he then proceeded to copy onto the canvas. Instead, we presume, he held in mind the results of his contemplations upon humanity and that these conditioned his act of painting. The act of painting for an artist like Bacon is also an act of 'seeing' brought into conjunction with the possibilities of the physical materials used. A blank canvas is an indefinite expression of all possibilities that is only made concrete by physically painting. "Triptych Inspired by the Oresteia of Aeschylus" depicts three different views of Figures related to a human being, but there is no way we can decipher these Figures from our everyday experiences, even though the background is readable as the wall of a room. This triptych suggests simultaneity through one Figure going through the door in the r.h. panel and emerging through the door of the l.h. panel, where the l.h. Figure, given the title of this work, would be one of the 'furies' that pursue humanity. Thus we are given a simultaneous image, from three different angles, of how an individual so troubled by their conscience appeared to Bacon from the stand-point of someone who was able to perceive how supersensible forces act from the plane-at-infinity.

Infinity, even though we are unable to perceive it as an object, is something we know because we are able to mathematically cognise it through Geometry, and is another concept that lacks a percept. Euclidean geometry, which lacks an awareness of infinity, was transformed by the inclusion of infinity, as the vanishing point, by the artistic development of perspective drawing, and then this paradigm was further developed by Descartes into what we know as Cartesian space. However an unconscious, in the sense of not being fully realised, awareness of infinity existed at the time of Euclid and this is demonstrated by Pappos and his theorem, for the concern of the Pappos' theorem is with **relationships** and not measurement, (Whicher, 1985: 103ff). The mathematical points in the Pappos' theorem float in a regulated, eternal bliss far away from the passions and pains of the material plane of existence. There can be little doubt that Pappos is instructing us from a thinking that still retains an awareness of conditions on the plane-at-infinity, and that this has subsequently been developed into what we know as Projective geometry, a geometry that permits us to cognise the organic world just as rigorously as the Cartesian paradigm permits us to cognise the inorganic world.

If we now imagine that we have reached the 'vanishing' point we would be part of, and on, that plane at infinity (bearing in mind that points become lines and that lines become planes) and consequently be infinitely large and simultaneously connected with everything that exists. Supposing then that we are now able to turn around and look back along the infinitely long path we had travelled, we would now see our starting-point as the 'vanishing'

point – as the point-at-infinity – but now we perceive from the aspect of simultaneity and inter-connectedness and not the separateness in time and space that characterised our previous position. A truly astounding difference, for all our previous suppositions would be seen in a, literally, entirely different light. Through these imaginations it is possible to turn an abstract, intellectual understanding of Lemniscatory space and its cross-over point into a living experience. Olive Whicher and George Adams make use of this figure to demonstrates how formative forces issue forth from the farthest reaches of the cosmos for the coming-into-being of the organic realm, thus meaning there is within every living thing 'points-at-infinity' towards which these forces can work. If one makes some headway in experiencing Lemniscatory space in this manner one at first realises that the 'apparently' homogenous space we inhabit in our everyday lives is anything but that, and that this space is in reality in states of extreme but ordered agitation moving in and out of itself as forms metamorphose into other forms in a bewildering display of the majesty of life. So when we walk through the world doing our daily business we are in the midst of an 'infinite' number of 'points-at-infinity', or 'vanishing' points, and these encircle and enfold us as much as the very air we breathe.

Having looked at how we are able to activate our imagination through determined acts of will so that it plays an energetic part in our conceptual life it is necessary to take note of other roles it performs of which we are not normally fully conscious. Principally this involves examining how our imaginative faculties are enfolded into our perspective vision of the world. When we look upon our surroundings what we see is an amazing array of phenomena regulated by their orientation towards points-at-infinity that we cannot perceive, but which find expression as 'vanishing' points in Classical perspective. The salient feature of the perception of these phenomena is that we only ever see *one aspect* of them there is always a part that is occluded, and this is true even if we pick an object up, we are never, under normal circumstances, able to cognise an object in its totality. The only way we know an object is the object it is, rather than something else that its configuration strongly suggests, is through our imagination that fills in the missing details in the manner of a mysterious and hidden artist. We become aware that this is the case through the many instances when there are mistakes in how cognise the world that are corrected through a second glance. One can even artificially create perceptual conditions that demonstrate this proposition by closing one eye and looking at objects from an oblique angle. Without our imagination, and purely by itself, our perspective vision is an intellectual construct that only partially reveals the surrounding world. One conclusion to be drawn is that the objects of perception are in fact configurations of light that we have intellectually abstracted from the totality of light that enters ours eyes, and upon which we project qualities, textures, smell and so on, so that we are able to comprehend them.

It is when we are in the receptive mode of consciousness, and subsequent phases, until the active mode comes to the foreground that all the information is gathered that consequently has to be supplied by our imagination so that we are able to function within the limitations of a perspective vision of the material world. The abiding characteristic of our receptive mode of consciousness in these first three years of earthly life is **unity,** as was outlined when the 'forgotten' self was spoken of above, and not the *atomisation* of reality that occurs when we develop our intellectual powers during the active phase. The imagination has the

ability to access these memories of our early years, so that in our adult life it can supply the absolutely essential qualities of phenomena, in addition to rendering objects complete, effectively rectifying the paucity of the intellect apprehension of the world. Nevertheless, despite severe limitations to the vision we now possess it is indeed miraculous, and it is down to the wisdom of Nature that infinity has been included within it, for without our vision as it has evolved we would be at a disadvantage in coming-to-terms with the inorganic realm, and, importantly, it is doubtful whether or not we would be able to progress further. It is because infinity resides within our vision as an 'absent presence' that can only be alluded to, that we have the possibility to develop our consciousness by taking cognisance of its unusual characteristics. Through the efforts of Olive Whicher, George Adams and Lawrence Edwards the vital role that Projective geometry has for an understanding of growth in the organic realm, and naturally this includes ourselves, has been made crystal clear and it is difficult to praise them enough for what they have achieved.

Another outcome of doing these exercises is that the prior intellectual belief of a dualistic universe is eroded and in its place arises the imaginative knowledge of not a dualistic but a *bi-polar* cosmos, and that there is no sharp distinction between ourselves and all that lives. Thus it is not just the minerals, plants and animals that are imbued with points-at-infinity but we are also. Ernst Lehrs eloquently elucidates this fact in his book "Man and Matter", and he shows that a primary Lemniscate lies within ourselves and operates from the brain to the metabolic system, and vice-versa, passing through the heart and the rhythmic system of the soul. From what has been said of the development of the child from infancy to adulthood, from a receptive mode to an action mode, this is in reality a journey through this Lemniscate out of the metabolic zone into the head zone, a journey that appraises us of the truth that every individual is an embodiment of the spiritual development of the human race. It would seem that because our 'ordinary' thinking is now predicated upon the intellectual, the inorganic and the lifeless, that it has lost all contact with primordial creative forces, a situation that if it were to be the case in reality would be utterly disastrous, is not actually how things are. The imagination, which maintains a link to the receptive phase of development, silently completes an otherwise god-forsaken, forlorn, mechanical vision of the universe, and presents us with opportunities, if we grasp them, to redeem – to resurrect – this vision from such a parlous state.

The sublime wisdom of Nature, referred to, in integrating infinity into our ordinary awareness is demonstrated by how we are, when awake, always aware of the horizon. This awareness never leaves us, we are 'locked' into it – an aircraft's instrumentation designed to keep it co-ordinated to the horizon is an unconscious technical manifestation of this wisdom – regardless of whether we are sitting in a windowless room, bending over, or whatever we never lose consciousness of the horizon imaginatively unless extreme artificial conditions are created to disrupt its functioning. It now becomes apparent that in our ordinary lives we are constantly passing through points-at-infinity as we move, act and integrate with others, and the Gestalt figure, referred to above, signifies this fact, for two contradictory *forms* co-exist simultaneously in *one and the same place* – a single plane - precisely one of the implications of the 'plane moving to infinity imagination'. In moving from one interpretation to the other we have to pass through a point-at-infinity, where the metamorphosis occurs, to come out on the other side with the counter meaning of the first. This understanding is

critical for our communal life, for another example of passing through a point-at-infinity is when in encountering the 'Other' we move out of our own individual 'I' consciousness, and all our personal concerns, and try to think, feel what it is like to be the 'Other' facing ourselves.

These thoughts elicit less obvious implications of Andrew Wellburn's comment that perspective vision serves to includes others, based upon of Jean Piaget's discovery that ego-consciousness occurs within the child around the same time as the development of perspective vision. Orientation is to a 'vanishing' point that lies upon the horizon, (line-at-infinity), an horizon that includes all other possible points from where any other person could orientate themselves. Given that the horizon is an ideal construction that stands-in for the line-at-infinity and that a 'vanishing' point stands for a 'point-at-infinity', then it follows that this horizon which consists of an infinitude of 'vanishing' points serves to bind us together. So is the next step in the evolution of consciousness to change the horizon and the 'vanishing' point into palpable realities, and thereby find a true communion with all that lives by banishing the illusion of separateness? As mentioned a common theme from the mid-19th. Century onwards amongst artists has been the attempt to get beyond a mimetic, perspective style of reproduction of the world and circumvent intellectual thought processes so as to find a mode of expression that reflects the ever evolving, consciousness of humanity. In this vein many strategies have been adopted to achieve this end, such as the recourse to children's painting and the work of 'primitive' cultures. This is indicative of an instinctual drive to recover originary states of being and consciousness, but this cannot mean a resurrection of how ancient humanity perceived the world - that would be a regression and a collapse into infantilism - instead what is required is that the imaginative, receptive phase of infancy (the 'forgotten' self) is permeated with the logic and reason we develop during the later intellectual, active phase.

Renewing the Past.

Deleuze was astute enough to recognise that Bacon reconstituted modes of representation belonging to past cultures: the haptic vision of ancient Egypt and the Gothic line. His account of Bacon's paintings also includes a whole chapter devoted to the hand and the eye, in this chapter he makes a distinction between four ways in which the hand may be deployed: the digital, the tactile, the manual proper and the haptic. Deleuze's argument is that the digital represents the maximum subordination of the hand to the eye:

"...vision is internalised, and the hand is reduced to the finger; it intervenes only in order to choose the units that correspond to pure visual forms. The more the hand is subordinated in this way, the more sight develops an 'ideal' optical space, and tends to grasp its forms through an optical code." 10.

This would be the situation where one produces a *ruled* drawing purely based upon the rules and principles of perspective. Such a drawing displays no individual characteristics and its purpose could be to appraise someone of the lay-out of a particular locale, but it is possible for this type of drawing to include visual referents, such as depth and relief, in which case Deleuze says it would display the tactile aspect of the hand. The reverse, where the hand has complete control, thereby subordinating the eye is where the hand works to demolish all optical codes, and this is what Deleuze calls the 'manual proper'. A balance occurred, in the past, with the haptic, where the hand displays properties of 'seeing' and the eye displays properties of 'touching', the secret of which has been lost according to Deleuze. (Deleuze, 2003: 155).

Deleuze argues that the digital - the blueprint-like - is ever present in the thinking of an artist, and this I would argue is true of everyone because our evolution to ego-consciousness required a perspective vision to reflect this fact as I have argued above. The 'digital hand' (left hemisphere), therefore, would be a tyrannical, unqualified submission of the hand to the abstraction of the intellect that defines the active mode of consciousness, whereas the 'manual proper' (right hemisphere) would be an anarchical display of the hand allied to the imagination of the receptive phase, but lacking any guidelines. These two aspects of the hand can be summed-up as 'I am knowledge but I lack being' for 'digital hand', with 'I am imagination but I lack truth' for the 'manual proper'. Deleuze goes on to claim that Bacon uses these two modes of the hand to create what he calls a 'catastrophe' that is not catastrophic by bringing about a collision between the 'digital hand' (figurative, mimetic form) and the 'manual proper';

"..one starts with a figurative form, a diagram intervenes and scrambles it, and a form of a completely different nature arises from the diagram, which is called the Figure". 11.

Through this technique Bacon has brought 'being' to the lifeless, moribund abstractions of the 'digital hand' whilst giving order to the lawlessness of the imaginations of the 'manual proper'. This achievement also included the rhythmic, systolic and diastolic movements that are characteristic of the cross-over point of lemniscatory space and where points-at-infinity can be identified in his work as the tips of umbrellas and the plug-holes of sinks. So Bacon has rehabilitated a haptic mode of painting through clear, logical, wide-awake thinking that

appeals to a modern consciousness. Up to the renaissance our awareness of points-at-infinity moved from an unexpressed acceptance of them in ancient cultures to an abstract, albeit it an abstraction that demonstrated their vital role in cognising the spatial world we inhabit, delineation of them within perspective drawing. Through Bacon's technique we can now recognise these points-at-infinity as being palpable presences, as 'organs of perception', that inform us of the interrelatedness, and not separateness, of humanity with each other and the organic world.

It might be argued that Bacon's work is mere representation and has no further value than that, and no doubt this is true of someone who only looks upon their surfaces and tries to find comparison with other works. However, to someone who is deeply affected by Bacon's images they are symbolic in the true sense of the word. Van James gives us an idea of this word's true sense and its derivation:

"The Greek word *symbolon* means to 'join what is separated, to join together'. The symbol, though often meaningless to the uninitiated, unites a sensory phenomenon to its supersensible reality by means of a picture."

He also states of the symbol that

"They appear before the use of letter signs and written words, as they precede abstract concepts and formal ideas. It is likely that in earlier times the meaning of a symbol was not grasped through the intellect, but through instinctual cognition and direct spiritual perception." [12]..

One of Bacon's most persistent claims was that he wanted to affect the viewer's nervous system, in effect to shock and wake-up. But this was not arbitrary and self-indulgent but meant to stimulate that side of ourselves (the 'forgotten' self of the receptive phase of development) that has been overshadowed and side-lined in terms of importance by our obsession to cognise the world through the lifeless, abstract concepts of the intellect alone. The effect of Bacon's images is thus to give a jolt to the right hemisphere that in turn destabilises assumptions as to how reality is constituted, thereby through causing the 'catastrophe' to be activated in his works and this results in a similar state being evoked in the viewer. Bacon's images act like a link, or a yoke, from our evermore sterile intellectual thinking to the vibrant imaginative world of the 'forgotten' self, so that, potentially, our intellect is enriched and an inherently unruly imagination is ordered with the result that the 'out of phase', or misaligned, nature of our consciousness has the potential to be healed.

Bacon's work provides an example of how works of art are a 'technology', the possibilities of which we have not even begun to grasp. Perhaps this appears a perverse definition of an art-work, but at present the term technology mainly covers the creation of machines for functional purposes, and as such obfuscates what we mean by human creativity. Everything we create results from ideas that find expression through the transformation of matter for specific purposes. One difference between a machine and an art work is that the machine has a clearly defined purpose from the outset and all further developments of it serve to make more fully manifest the possibilities of this original combination of idea and purpose: the latest version of a Porsche is a more effective means of expressing the concept of a

car than a Ford Model T of the 1920's. The purpose of an art-work generally, and in most cases to the person creating it, is ill cognised, this is one reason why Bacon's images are so compelling because he fully understood his purpose and he strove to find the most effective means of expression. The monuments of the ancient world, ranging from Stonehenge to the pyramids of Egypt, had the explicit purpose of making manifest through the arrangement of matter, humanities spiritual origins and connection to the spiritual worlds. Thus a revision of what we mean by technology means that from a modern viewpoint these ancient monuments were the first technology, and we only find this strange because we think of technology as only relating to machines, and not all of human creativity. If this reasoning has any validity then it follows that one possible outcome of revising the epistemological status of art works will lead to a machine-technology that is in harmony with the progressive aspects of the creative cosmos, because our Art would then perform the same function that the monuments of the ancient world had for its peoples.

If according to these conjectures Francis Bacon had the experiences suggested then they must have come as a complete revelation that changed his whole outlook on life, after which he struggled to find modes of expression that would adequately encapsulate that which he perceived. This was no easy task and he spent much of his earlier life experimenting, learning and studying until he found a style accessible to the public. This analysis has demonstrated that the results of his researches become comprehensible through the postulations concerning 'invisible' realms described above. The opinion is that Bacon had a definite phlegmatic side to his character, and that he conducted his researches into human nature with the same philosophic objectivity and rigour as that of a scientist. This opinion is borne out and vindicated by John Russell's impression of Bacon demeanour,

"Francis Bacon's clean-shaven face, at once chubby and tormented, and as roseate as that of some eighteenth-century English empirical philosopher discoursing over his brandy or his sherry, seems to reflect wide-eyed astonishment as well as intellectual stubbornness and – allied to a hidden fury – the sensitive distress of a man who has not forgotten that he was once a child whom almost anything could move to wonder."

"Perhaps, this same rejection of ready-made solutions is indicated by his slightly askew – or, at any rate, not at all full-frontal – stance in many of his photographs." 13.

There is no need to say anything further on Russell's perceptive comments in view of this text, but there is one further twist to this interpretation that has profound implications if taken seriously. Bacon when questioned about his ancestry gave the following reply

"Amongst all the people they thought might have masqueraded behind the name of Shakespeare was the Francis Bacon who lived at that time, and to whom my family is related, according to my father." 14.

The 'Francis Bacon' that Bacon refers to is widely credited with having played an important part in the formulation of what we now call the 'scientific' method, and who also advocated that Nature is a resource to be mined and used purely for human ends. This is also the moment from which, henceforth, the human body will only be perceived as a dense, machine-like compaction of forces, and so some 400 yrs. after his namesake, Bacon through

his intense aesthetic thinking gives us a very different picture of the human being than the mechanical model that has devolved from Enlightenment postulations of 'Man as Machine'. In effect Bacon shows that empirical research - thinking about perceptions - can run a very different course when our imaginative faculties are given their due credit, and we eschew fitting what we perceive, if the evidence is contradictory, into preconceived notions.

The calibre of Bacon's thinking, and the fact that it is reflected in the composition of his images, is surely one of the reasons for David Sylvester making the effort to set-up a style of interviewing that unambiguously recorded Bacon's statements, without which interpretation would have been all that much more speculative. But another reason for Sylvester doing this, and this is true of other viewer's fascination with Bacon's work, is that Bacon's images intimate an almost ineffable knowledge of the human being, combined with an ineluctable drive to make this knowledge manifest. What are we then to conclude about an individual who was able to combine a passionate nature with the sobriety of a scientist and a philosopher, perhaps Michael Peppiatt got it about right when he subtitled his biography of Francis Bacon as 'Anatomy of an Enigma'.

Any questions concerning this text may be addressed to me by email

Notes.

1. Schmeid, 2006. 20.

2. Schmeid, 2006. 27.

3. Sweite, "Language of Violence", 2007. 233.

4. Sweite, "Language of Violence", 2007. 232.

5. Sylvester, 1987: 71.

6. Bortoft, 2004: 15-16.

7. Wilson, 1998.

8 Edwards, 1979: 37.

9. The American psychologist Benjamin Libet conducted a series of experiments where subjects were asked to make a decision to move their hand and then record the moment of this decision via a stopwatch. Libet found through scalp electrodes that neural activity commenced a fifth of a second prior to the subjects being conscious of making a decision. I have been arguing that our 'normal' consciousness, through a consideration of the implications of 'thinking about thinking', is a state that is 'out of phase' with other aspects of our being, and Libet's experiment points to such a disjunction within our consciousness. As well as raising questions over intentionality this experiment also delineates the confusion that arises through considering a perception as being of the same order as a representation A perception of a red rose is purely that and is a living interaction with that rose, and although the first time I perceived a red rose is lost to memory it nevertheless remains and resurfaces when I see another red rose. I do not make a representation of a red rose which is then pasted onto what is perceived, a representation of a rose is a consciously willed mental act that has a different relationship to an actual rose than does its direct perception.

10. Deleuze, 2004:154-55.

11. Deleuze, 2004: 156.

12. Van James, 2001: 126.

13. Russell, 1997: 169-172.

14. Archimbaud, 1993: 120.

List of Illustrations. (F. Bacon)

List of Illustrations. (P. Miles)

Condensation and the Fall

Sexuality and the Holy Mother.

Garden of Earthly Delights: Triumph over Deception.

Flight and Transformation.

Portal of Renunciation.

Bibliography.

Adams, G. and Whicher O. The Plant between Heaven and Earth. 1980, The Rudolf Steiner Press.

Alphens, Ernst van. Francis Bacon and the Loss of Self. 1992, Reaction Books Ltd. London.

Archimbaud, M. Francis Bacon. 1993, Phaidon Press Ltd. London.

Barthes, Roland. "The Death of the Author" in Image, Music, Text, ed. Stephen Heath. 1977,

Hill and Wang, New York.

Baudrillard, J. The Anti-Aesthetic, etd. Hal Foster. Bay Press, 1983. Seattle.

Berman, Marshall. All that is Solid Melts into Air. 1982, Verso, London.

Bochemuhl, J. ed. Toward a Phenomenology of the Etheric World. 1985, The Anthroposophic Press.

Bogue, Ronald. Deleuze and Guattari. 1989, Routledge, London.

Bornedal, P. The Interpretations of Art. 1996, University Press of America. London.

Bortoft, H. The Wholeness of Nature. Goethe's Way of Science. 2004, Floris Books.

Boundas, Constantin & Olkowski, Dorothea. Gilles Deleuze. 1994, Routledge, London.

Braidotti, Rosi. Nomadic Subjects. 1994, Columbia University Press, New York.

Braidotti, Rosi. Patterns of Dissonance. 1991, Polity Press, Cambridge UK

Brighton, Andrew. Francis Bacon. 2001, Tate Publishing.

Brunton, Paul. 1987, The Notebooks; Human Experience, the Arts in Culture. NY, Larson Publications.

Butler, Christopher. Early Modernism. 1994, Oxford University Press, Oxford.

Butler, Judith. Bodies that Matter. 1993, Routledge, London.

Burgoyne, R.; Flitterman-Lewis S.; Stam R. New Vocabularies in Film Semiotics. 1992, Routledge. London.

Caygill, H. Walter Benjamin. 1998, Icon Books. Cambridge.

Cahoone, L. From Modernism to Postmodernism. 1996, Blackwell Publishers Ltd. Oxford.

Davies, Hugh. Francis Bacon: 1928-1958, 1978, Garland Publishing Inc., New York.

Deleuze, Gilles. Francis Bacon: The Logic of Sensation. 2004, Continuum, London.

Deleuze and Guattari. Anti-Oedipus. 1984, The Athlone Press, London.

Docherty, Thomas. Alterities. 1996, Oxford University Press, Oxford.

M. Dumas and F. Bacon. Malmo Konsthall. 1995.

Eagleton, Terry. The Ideology of the Aesthetic. 1990, Blackwell Publishers, Oxford.

Edwards, Betty. Drawing on the Right Side of the Brain. 1979, Fontana/ Collins. London.

Farson, Daniel. Soho in the Fifties. Pimlico, London.

Featherstone, Mike, Hepworth, Mike and Turner, Bryan. The Body. 1996, Sage Publications, London.

Fink, B. The Lacanian Subject. 1995,

Fitzgerald, A. 1996, An Artist's Book of Inspiration. Hudson, NY: Lindisfarne.

Flew, A. Western Philosophy. 1971, Thames and Hudson. London.

Flew, A. *Dictionary of Philosophy*. 1976, Pan Reference Books. London.

Foster H. The Return of the Real. 1996, The MIT Press. Massachusetts.

Foster H. Recodings. 1996, Bay Press. Seattle.

Foucault, Michael. "What is an Author?" in Language, Counter-Memory, Practice, ed.

Freedburg, D. and De Vries, J. Art in History: History in Art. 1987, University of Chicago Press.

Freud, S. On Sexuality. Penguin, 1977. London.

Freud, Sigmund. The Three Essays on Sexuality. Standard Edition, vol. 7.

Frosh, S. Identity Crisis. 1991, Macmillan Press Ltd. London.

Furedi, Frank. Therapy Culture. 2004, Roultledge, London.

Gallagher, C.; Lacqueur T. The Making of the Modern Body. 1987, University of California Press. London.

Goodchild, Philip. Deleuze and Guattari. 1996, Sage Publications, London.

Godfrey, T. Conceptual Art. 1998, Phaidon Press Ltd. London.

Grosz, Elizabeth. Volatile Bodies. 1994, Indiana University Press, Indianapolis.

Grunewald, Peter. Gold and the Philosopher's Stone. 2002, Temple Lodge.

Harris, Jonathan and Harrison, Charles and Frascina, Francis and Wood, Paul. Modernism in Dispute. 1993, The Open University, London.

Harrison C.; Gaiger, J.; Wood, P. Art in Theory, 1815- 1900. 1998, Blackwell Publishers Ltd. Oxford.

Harrison C.; Gaiger, J.; Wood, P. Art in Theory, 1900-1990. 1998, Blackwell Publishers Ltd. Oxford.

Held, D. Introduction to Critical Theory. 1980, Hutchinson. London.

Hewison, R. Future Tense. 1990, Methuen Paperback. London.

Heywood, J. Social Theories of Art. 1997, Macmillan Press Ltd. London.

Howard, A. Thinking about Thinking. St. George Publications. Spring Valley, New York 10977.

Husemann, Armin. The Harmony of the Human body. 2002, Floris Books.

Jay, M. The Dialectical Imagination. 1973, Heinemann Educational Books. London.

Jay, Martin. Downcast Eyes. 1993, California University Press, London.

Jefferson and Robey. Modern Literary Theory. 1997, B.T.Batsford Ltd. London.

Kohut, H. The Restoration of the Self. International Universities Press, 1977. N.Y.

Lacan, J. The Four Fundamentals of Psychoanalysis. Penguin, 1977. London.

Laplanche and Pontalis. Language of Psychoanalysis. Karnac Books, 1988.

Lechte, J. J. Kristeva. Routledge, 1991.

Lehrs E. Man or Matter. 1985, Rudolf Steiner Press.

Leslie, Richard. Surrealism. 1997, Tiger Books International PLC, Twickenham.

Lunn, E. Marxism and Modernism. 1985, Verso. London.

Karl, Frederick R. Modern and Modernism. 1985, Macmillan Publishing Company, N. Y.

Kutzli, R. Creative Form Drawing I. 1981, Hawthorn Press, Gloucester, UK.

McGee, P. Cinema, Theory, And Political Responsibility in Contemporary Culture. 1997, Cambridge University Press. Cambridge.

Mees, L.F.C. Secrets of the Skeleton. 1984, The Anthroposophic Poress.

Mirzhoeff, Nicholas. Bodyspace. 1995, Routledge, London.

Moi. T. The Kristeva Reader. Basil Blackwell, 1986.

Moore, B.; Fine, B. Psychoanalysis; The Major Concepts. 1995, Yale University Press Ltd. London.

Moxey, Keith The Practice of Theory. 1994, Cornell Paperbacks, New York.

Oliver, K. Reading Kristeva. Indiana University Press, 1993.

Peppiatt, M. Francis Bacon. 1996, Weidenfeld and Nicolson.

Popkin, R. & Stroll, A. Philosophy. 1986, Heinemann. London.

Powell, T.G.E. The Celts. 1987, Thames and London.

Radin, Dean. The Conscious Universe. 1997. HarperCollins Publishers. N.Y.

Rothenstein, J and Alley, R. Francis Bacon. 1964. Thames and Hudson.

Russell, J. Francis Bacon. Thames and Hudson, 1997. London.

Sarup, M. Post-Structuralism and Post-Modernism. Harvester Wheatsheaf, 1993.

Schwenk, T. Sensitive Chaos. 1976, Rudolf Steiner Press.

Schmied, Wieland. 2006, Prestel Publishing Ltd. London.

Scruton, R. Modern Philosophy. 1994, Reed Consumer Books Ltd. London.

Stein, W.J. The Ninth Century and the Holy Grail. 2001, Temple Books. London.

Steiner, R. A Psychology of Body, Soul and Spirit. 1999, The Anthroposophic Press.

Steiner, R. A Road to Self Knowledge, The Threshold of the Spiritual World. 1975, The Rudolf Steiner Press.

Steiner, R. An Outline of Occult Science. 1997, Anthroposophic Press.

Steiner, R. Atlantis. 2001, Sophia Books (Rudolf Steiner Press).

Steiner, R. A Theory of Knowledge. 1978, The Anthroposophic Press. N.Y.

Steiner, R. Cosmosophy vol. 1. 1985, Anthroposophic Press.

Steiner, R. Egyptian Myths and Mysteries. 1971, Anthroposophic Press.

Steiner, R. Esoteric Development. 1982, The Anthroposophic Press.

Steiner, R. From Beetroot to Buddhism. 1999, Rudolf Steiner Press.

Steiner, R. Goethe's World View. 1985, Mercury Press. N.Y.

Steiner, R. Goethean Science. 1988, Mercury Press. N.Y.

Steiner, R. Isis Mary Sophia. 2003. Steinerbooks, Great Barrington MA 01230 USA.

Steiner, R. Knowledge of the Higher Worlds. 1993, The Rudolf Steiner Press.

Steiner, R. Metamorphoses of the Soul, vol. 2. 1983, The Rudolf Steiner Press.

Steiner, R. Philosophy, Cosmosophy and Religion. 1984, Anthroposophic Press.

Steiner, R. Riddles of Philosophy. 1973, Anthroposophic Press.

Steiner, R. Secrets of the Threshold. 1987, Rudolf Steiner Press.

Steiner, R. Study of Man. 1981, The Rudolf Steiner Press.

Steiner, R. The Evolution of Consciousness. 1991, The Rudolf Steiner Press.

Steiner, R. The Fourth Dimension. 2001, Anthroposophic Press.

Steiner, R. The Kingdom of Childhood. 1982, The Rudolf Steiner Press.

Steiner, R. The Occult Significance of the Blood. 1926, Anthroposophical Publishing Company, London.

Steiner, R. The Philosophy of Spiritual Activity. 1986, Anthroposophic Press.

Steiner, R. The Riddles of Philosophy. 1973, The Anthroposophic Press. N.Y.

Steiner, R. Theosophy. 1989, The Rudolf Steiner Press.

Steiner, R. Truth and Knowledge. 1981, Steinerbooks.

Steiner, R. Universe, Earth and Man. 1987, The Rudolf Steiner Press. London.

Stevens, R. Understanding the Self. 1996, Sage Publications Ltd. London.

Stoichita, V. A Short History of the Shadow. 1997, Reaktion Books Ltd. London.

Sylvester, D. The Brutality of Fact. 1987, Thames and Hudson. London.

Sylvester, D. Francis Bacon: The Human Body. 1998, University of California Press. London.

Sylvester, D. Interviews with Francis Bacon. 1993, Thames and Hudson.

Sylvester, D. Figurabile. Electra, 1993.

The Violence of Real" various authors. 2007 Thames and Hudson. London.

Tilley, Christopher. Reading Material Culture. 1991, Basil Blackwell Ltd., London.

Urieli, B. L. and Muller-Wiedemann, H. Learning to Experience the Etheric World. 2000. Temple Lodge.

Wayne, M. Theorising Video Practice.1997, Lawrence and Wishart Ltd. London.

Wehr, G. Jung and Steiner. 2002, The Anthroposophic Press.

Welburn, A. Rudolf Steiner's Philosophy. 2004, Floris Press.

Weigel, Sigrid. Body- and Image- Space. 1996, Routledge, London.

Whicher, O. Projective Geometry. 1985, The Rudolf Steiner Press.

Whicher, O. Sunspace. 1989, Rudolf Steiner Press.

Wilson, F. The Hand. 1998.

Wright, E. Feminism and Psychoanalysis. Blakewell Reference, 1992.

Wolin, R. Walter Benjamin.

Van James. Spirit and Art. 2001, Anthroposophic Press. Great Barrington, MA 01230.

This short dissertation upon the painter Francis Bacon, () is an uncompromising deployment of the ideas of Rudolf Steiner, () Austrian philosopher, concerning the spiritual constitution of the human being for explanatory and interpretive purposes. This very fact will be anathema to some people, but those of an open-mind will be intrigued, as I am, by how some of Steiner's central concepts are reflected in such modern-day theorists such as Gilles Deleuze and Julia Kristeva, quite apart from the fact that Bacon expressed a similar understanding through the 'language of Art'. I have been studying Francis Bacon's *oeuvre* for over 15 years and I believe that it is not possible to fully understand his paintings without a concrete spiritual dimension to my *critique*. Rudolf Steiner put forward such a concrete spiritual understanding, as highlighted in the text. Because this text has arisen from my researches it thus exhibits a relentless intellectual format, and so the inclusion of my drawings are meant to provide both a breathing space and to illustrate how I perceived the subject-matter of the text in my twenties and nothing else.

Cover design: P.T.Miles

Illustrations: P.T.Miles.

Website: artskape.co.uk

Email: artskape@tiscali.co.uk.

About the Author

P.T.Miles studied Fine Art at Newcastle upon Tyne University, Great Britain. He later attended Leeds Metropolitan University where he obtained his M.A. (Critical Studies). His book has developed from his research during this period. He has had numerous exhibitions at various Galleries. and is at present a practising artist living in West Yorkshire, Great Britain.